The Art of Print Making

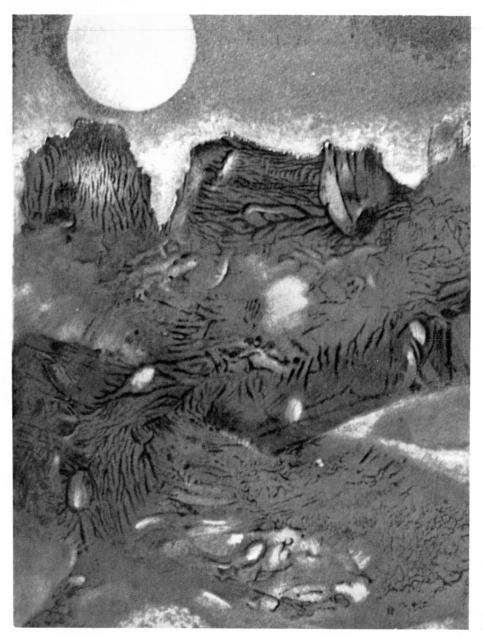

Rocky landscape with moon
Max Ernst. Aquatint.

The Art of Print Making

A comprehensive guide to graphic techniques

Erich Rhein

VNR VAN NOSTRAND REINHOLD COMPANY

NEW YORK CINCINNATI TORONTO LONDON MELBOURNE

This book was originally published in German under the title
Die Kunst des manuellen Bilddrucks by Otto Maier Verlag, Ravensburg,
Germany
Copyright © Otto Maier Verlag 1956
English translation © Evans Brothers Limited, London, England 1976
Translated from the German by Neil and Roswitha Morris
Library of Congress Catalog Card Number 74-14089

ISBN 0-442-26900-5

Published in 1976 by Van Nostrand Reinhold Company
A Division of Litton Educational Publishing, Inc.
450 West 33rd Street, New York, NY 10001, U.S.A.

Van Nostrand Reinhold Limited
1410 Birchmount Road, Scarborough, Ontario M1P 2E7, Canada

16 15 14 13 12 11 10 9 8 7 6 5 4 3 2 1

Library of Congress Cataloging in Publication Data

Rhein, Erich.
 The art of print making.

 Translation of Die Kunst des manuellen Bilddrucks.
 Bibliography:
 1. Prints—Technique. I. Title.
NE850.R513 760'.028 74-14089
ISBN 0-442-26900-5

Introduction

Develop an infallible technique and place yourself at the mercy of inspiration.
Zen Buddhism

Definition Nowadays the phrase 'graphic arts' is often used as a generic term to cover all those arts which depend for their effect on drawing, although strictly it should only be applied to the various techniques of pictorial reproduction; in other words, it covers all the methods of 'multiplying' prints. We shall exclude here the mechanical reproduction processes, restricting the term to those methods of printmaking in which the artist himself is manually involved. Graphic art is proving increasingly popular in art lessons and this book outlines the methods practised in schools, particularly those which in their simpler forms will also appeal to the amateur artist.

Aims This book is therefore intended for artists, art students and craftsmen, for art teachers in schools and colleges of all types, as well as for all those who are generally interested in art, regardless of age or profession.

It is hoped that the reader will be encouraged to try some of the graphic techniques and learn to appreciate the unusual results and knowledge to be gained from everyday life. The most important graphic techniques—the simple as well as the more complex ones—are explicitly illustrated, and the various printing stages are described, from the first design to the final print image.

This book should not be regarded simply as a technical manual, however, but also as a means of sharing artistic experiences and offering ideas for development by teachers and students. Those who are prepared to set out on their own voyage of discovery, making their own graphic experiments, will benefit from it most. A book, of course,

can never replace a good teacher. The arrangement of the subject matter into short, self-contained sections, essential in the case of a book, is replaced in art lessons by a more personal relationship between teacher and student, taking into account their individual needs, tastes, talents and stages of development and, above all, the contemporary needs of education. This will be touched on later, in the section 'The importance of graphic techniques with regard to art-teaching'.

Whether the reader selects those passages in which he is most interested first, or whether he works systematically through the book, is of little importance. Practice and experiment kept under constant review will automatically lead to progress in the mastery of technical and artistic media and will prevent the graphic techniques from deteriorating into mere effects or the pointless imitation of nature or other art forms.

After certain stylistic periods shifted the artistic weight on to other art forms, original works of graphic art are today enjoying a resurgence of interest. In fact, there is little doubt that the art historians of the future will have to devote a large chapter to the renaissance of pictorial hand printing in our technicological and industrial age. The momentum for this renaissance is provided by the current interest in experimentation and discovery, and an awareness of elementary forms of artistic design. Its outward manifestations are an increasing number of graphic art exhibitions; books and magazines about the graphic arts and applied graphics; the distribution of artist-produced prints as annual donations by some cultural societies, museums, competitions and etching groups; and last but not least a generally more positive attitude towards contemporary works of graphic art, which are bought for both decorative and investment purposes. These are all pleasing indications.

Graphic art and applied graphics are also often regarded as stepping-stones to the understanding of modern art. In as differentiating an age as ours it is more difficult than ever to make objective value judgements; active participation in graphic techniques must therefore lead to a greater appreciation of the graphic medium, the methods, the means of expression and the tools employed. It will not only give technical information, but will develop a sense of quality and provide creative experiences which will be reflected in all the other fields of art and design, and which cannot be acquired by reading books, but only by one's own effort.

Erich Rhein

Hanover, 1956

Beauty is the lustre of truth.
Saint Thomas Aquinas

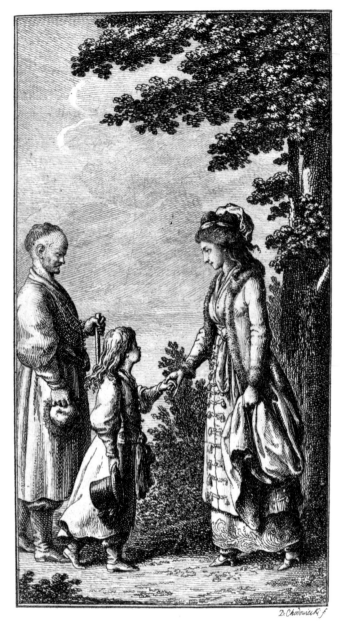

Greeting Daniel Chodowiecki. Copper engraving.

8

Foreword

Almost all artists have been attracted by the art of manual picture reproduction. Again and again painters and sculptors have been intrigued by the graphic medium, and have sought and found ways of expression which could not be realized in their paintings or sculptures. It is therefore not surprising that artists, having set their own boundaries, have dedicated their whole lives to the graphic arts. We need only think of the artists of China and Japan, of the wood and copperplate engravers of the 15th and 16th centuries, of Hercules Seghers, Callot, Paranesi, Chodowiecki, and Kubin. All of them were exclusively graphic artists, and yet their achievements equal and possibly surpass the work of many important painters and sculptors.

The creative process of graphic art can be very adventurous. More than in any other art form, the outcome of the work is uncertain until the very last moment. Although it is possible to follow the development of the design on the stone or wood-block, or on the zinc or copper plate, the artist cannot tell whether the picture is progressing as desired, and only when the first print is made can he see whether it is a success or requires alteration.

All these factors—the workshop atmosphere, the dissemination of prints, which is as active now as it was in the early days of printing, the desire for one's work to be exhibited alongside paintings—would be pointless if there were not also some deeper involvement. And this is provided by the effort to seek order and clarity in times of spiritual uncertainty and verbal confusion. The fear of appearing unfashionable, which affects so many people today and harasses them into making errors of judgement, is a fear of life itself. We should leave 'fashion' in the hands of the dress designers, and aim to help things mature and bear fruit in their own good time. We can thus avoid superficiality and look beneath the surface to find the truth.

Karl Rössing

Contents

Three starting points

The perfect man acts without inducement, creates without matter, devises without a goal.
81st saying of Lao-Tse

It is not the goal which is of interest, but the means with which to achieve it.
Georges Braque

As a suitable starting point for art education I envisage an equilateral triangle, at the three angles of which we find arranged in equal importance:

A. Experiments with media;
B. Abstract composition;
C. The study of nature.

It is essential that A, B and C should be given equal consideration; to neglect any one of them might well lead to the collapse of the whole construction.

Despite their great importance, however, these three points are only peripheral. All creative art must have man himself as its centre and ultimate point of departure. Thus our work must be based on a sympathetic understanding of our own desires, our abilities and limitations and the dangers with which we are faced. This is indeed a wide field, but it is of the utmost importance.

The three points of the triangle do not present a standard formula for devising experiments and exercises. Individual gifts and inclinations, the prevalent educational situation and the personalities of both pupils and teachers must be given the fullest consideration and be kept under constant review.

Because of their significance within the whole scheme, each of the three starting points will be considered separately in the following sections.

A Experiments with media

In every man there lurks a child wanting to play. The most elementary introduction to the technical and pictorial aspects of graphic art is achieved through aimless and non-objective games with its media and tools. We will encounter this idea again in the chapter on 'Introductory graphic techniques', page 34, and in other places throughout the book.

In his letters entitled *On the Aesthetic Education of the Human Race* (1795), Schiller pointed out that form was discovered most readily by children giving free play to their mental perception. It was not without reason that Itten introduced the purposeless manipulation of shapes into the *Bauhaus* curriculum, and it has since been incorporated in most art and craft school curricula. 'For man only plays when he is, in the true sense of the word, a man, and he is only a complete man when he plays,' wrote Schiller. Certainly, adults do not usually carry on playing, though the importance of play to the development of all man's physical and mental faculties was praised by Jean Paul in his poem *Levana* and was scientifically proved in his experiments on both human beings and animals by Karl Groos, the biologist from Tübingen.

Play relaxes and stimulates; it sparks off ideas and creates knowledge; it reveals the

'rules of the game', which are carried over into serious actions and can then be regulated and applied to work. Play provides us with chance, and it is of the utmost importance to make use of it. Both the teacher and the artist must always keep an open mind, looking both inwards and outwards.

Improvisation is the development of chance resulting from play, which is the basic source of all creative activity; both play and improvisation give life to man's intuition and stimulate his plans. In the creative act; feeling and understanding, the conscious and the uncoscious, are released in exciting succession.

In his treatise on painting, Leonardo da Vinci challenged the painter to use his imagination, 'to present a newly discovered way of looking which, though it may appear simple and almost ridiculous, will nevertheless be extremely useful in arousing the spirit to various discoveries'. From looking at ruins or stones of different composition the painter should discover landscapes, figures, facial expressions and battles, 'which he must fashion into their complete and proper form'. Baumeister writes in his work *The Unknown in Art* about 'seeking and finding', and about 'the vision': 'Saul set out to find his father's asses and found a kingdom . . . the original artist leaves behind what he knows and what he can do. He pushes on towards nothingness. And here begins his higher existence . . . Unlike the epigones[1] who know what they want and can do, since they have the completed pictures before them as a guide.'

Is the illustration on page 18 a product of pure chance? A student polishing a zinc plate suddenly scored it with a damp pumice stone and printed it on paper without adding anything to it. In this monoprint the secret of creative development is revealed; the rhythmic traces of water, zinc and stone recall in their magical arrangement the landscapes of oriental brush-drawings. They undoubtedly show rhythm. However, rhythm with its regularity is in fact the antithesis of chance and arbitrariness. Its essence escapes conceptual understanding, but reveals itself to the empathic openness to which relaxed play often leads. Rhythm plays an outstanding and mysterious part in art and artistic experience. The word rhythm is derived from the Greek 'rheein', to flow, and means streaming along, dancing lightly, following a chosen course. All that is stiff, stuttering, inhibited, cramped, inflexible and dead, is not rhythmic. There is a profound relationship between rhythm and life, whereas life and intellect can be at great variance with one another.

[1] Lesser folk of later times.

Structural invention. Lines around rectangular obstacles.

Colourful surface division with glued-on pieces of paper.

Ludwig Klages provides a sensitive treatment of rhythm in *Intellect—the adversary of life* and identifies the opposite poles of rhythm and beat. Rhythm is an expression of the unity of man; it has an organic effect and can be experienced in temporal, aural or spatial vibrations. Beat has no life, but is a mechanical, man-made, organizational principle, a manifestation of the human intellect, not arranging but separating. Beat implies break and separation; rhythm, flowing union. Beat amounts to compulsion, inflexibility, sameness.

Play opens up several ways for sympathetic consideration, and I should like to mention ink-blot printing in this context. Almost everyone has at one time or another experi-

mented with ink-blot tests and then interpreted the resulting symmetrical shapes. Justinus Kerner, a poet, visionary, doctor and philanthropist, whose musical gifts were praised by his contemporaries, created—when he was old and almost blind, ink-blot prints of the *Scenes from Hades*. He blotted sheets of paper with ink, coffee-grounds and berry juice, then folded and squeezed the paper, and was delighted with the resulting ink-butterflies and moths, and the ghostly grimaces of beasts and devils.

Line and surface rhythm developed from a continuous line.

Sometimes he added to them with imaginative brush strokes and made up rhymes to fit their fantastic shapes.

There are various ways and means to reveal the 'strength and healing power of petty activity' (Kükelhaus). Among them are the unconscious telephone doodles, which are often surprisingly decorative. They are a reflection of the subconscious, and in some way represent scribblings from the soul.

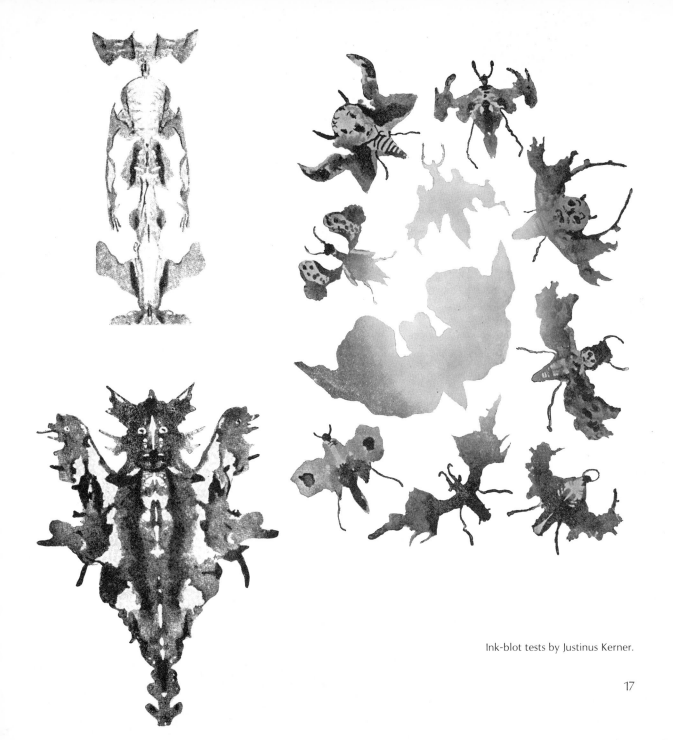

Ink-blot tests by Justinus Kerner.

An attractive chance result.

From doodling we learn that it is not always best to have only the ultimate goal in mind. There is also a kind of aimless perception; we must endeavour to create productive starting points which will of their own accord release the 'psychic automatism', as Itten once technically but accurately described it. The story of the millipede serves to show that intuition can be inhibited by over-acute awareness. A millipede, greatly admired for its wonderful walking rhythm, was once asked if it ever thought as it went along when to raise its hundred-and-twentieth left leg and when to raise its hundred-and-seventy-fifth right leg. Surprised, it replied that it had never done so up till now, but then it began to think about it and has since not been able to move from the spot.

Klee, Kubin and many other artists have often begun their works with no particular goal in mind. This is not to say that no conventions, either conscious or subconscious, were observed; there can be no game without rules. The importance of this experimental and artistic risk is more obvious in graphics than in painting and sculpture, since it involves the flexibility of play. The great masters of modern graphic art—Picasso, Klee, Moore, Braque, Miró, Rouault, Clavé and Chagall, to name but a few—have seen graphics as a field for experimentation within the mainstream of their art. And yet—or perhaps because of this—modern graphic art is often considered to be the most vital facet of contemporary art.

The greatness and perfection of art do not depend on the greatness and perfection of the means, but on those of the artist.
Hans Pfitzner

B Abstract composition

The craving for abstraction is at the inception of all art and remains predominant with certain highly civilized peoples.
Worringer: *Abstraction and Empathy*, 1906

By playing aimlessly with materials and tools one discovers almost unconsciously the possibilities of graphic techniques and their appropriate use. In general, experimenting with media is, therefore, a very suitable beginning. But the time will come when this will give rise to the desire to forestall chance and consciously to create certain artistic effects, and then the student should exploit the technical knowledge gained from his free play with materials and tools.

Two paths are open to him, that of abstract composition or that of translating representational forms into the language of the chosen graphic technique. Very little advice can be given here, as the wide field of drawing is not the theme of this book. There is also a great deal of literature on the subject—books on formal drawing techniques, theoretical and psychological investigations ranging from books about children's scribbles to purely technical handbooks. This area must be touched on here, however. There are graphic techniques which by their very nature—for example through the materials or tools employed—incline strongly towards abstraction. They have their own latent stylistic power. Abstract composition is met by a so-called 'absolute' artistic drive, as revealed in its purest form in ornamental work, where the content cannot conceal the artistic elements and where no representational portrayal of the outside world is created. For example, arrangements of dots in rows, in circles or scattered all over the paper, the revelation of linear or planar tensions, contrast and harmony expressed in geometrical shapes or rhythmic forms, portraying an uninhibited confirmation of one's individual life style, all belong in this category. Those who are concerned with 'absolute' art frequently refer to its affinity with music.

A conscious training in the use of form concentrated on non-objective elements, black and white combinations, grey and surface effects, is exceptionally useful. Here the balancing effects of open and closed compositions can be assessed, and pressure, dislodgement, light and shade, and arrangement of patterns can be tried out. Anyone

Abstract composition. Variations on the theme.

Chemistry Semi-abstract sketch with variations.

Pen-and-ink sketch
drawn from imagination

Watercolour painted
at the location.

who has been through this type of training and has previously indulged in experimental play with materials and tools will not only have acquired a good basis for abstract art, but will also find himself inspired in the field of representational art.

Man can only find rest in abstract, ordered shapes in the face of the monstrous confusion of his view of life.
Worringer: *Abstraction and Empathy*, 1906

C The study of nature

There is no such thing as abstract art, one must always begin with the object. Afterwards one can obliterate all traces of reality . . .
Picasso

A rather one-sided emphasis on the abstract use of form, symptomatic of our time, will of course not please all creative artists. Miró expostulated: 'They want to draw like us and yet they can't even draw an old boot'. Paul Klee wrote: 'Take your students out into nature, back to nature . . . Let them experience how a bud develops, how a tree grows, how a butterfly emerges, for them to become as rich, as flexible and as capricious as magnificent nature itself. Observation is revelation, a glance into the workshop of creation. That is the secret'.

Oskar Schlemmer, one of the masters of the *Bauhaus*, advised: 'Study nature, absorb it deeply and fully, and then reproduce the inner vision'.

In 1911 Barlach wrote to Kandinsky, concerning the latter's book *The Spiritual in Art*, '. . . as a barbarian I might believe the honourable man who claims that spots, lines, dots and flecks arise from the inner turmoil of his soul, but I shall only believe—and then, goodbye! We could talk for a thousand years without communicating! . . . My native tongue happens to be the human figure or the environment, the medium through which or in which man suffers, rejoices, feels or thinks'.

Artists such as Barlach, Klee, Schlemmer, Mirò and many others guarantee that the study of nature consists of neither mindless copying nor dead academicism. Photography has also made a valuable contribution to this new way of seeing. The pioneering work of Moholy-Nagy and Herbert Bayer of the *Bauhaus* should be pointed out in this context, as representatives of international attempts to achieve 'absolute photography' of a 'subjective objectivism'.

A contemporary study of nature must include the broader and changed concept of nature which results from the turbulent developments of our time. Visual experiences such as micro- and macro-photography, X-ray photographs, radiation, pictures, graphic symbols, visibility of what was formerly invisible or too fast all expand our conception of nature in hitherto unforeseen directions and provide much food for thought. The transition of sounds and pictures and the interchangeability of temporal and spatial relationships are used a great deal in magazines and films and are also accepted without demur by their audiences. If the spectator can in fact accept an objective representation (film and photography) of this new nature, he should not be afraid of coming to terms with a 'newly shaped nature'. He should try to sympathize with the aims and respect the intellectual achievement, even if the form seems unusual.

There was no perspective in paintings before the Renaissance. During and after the Renaissance the discovery of perspective proved a decisive influence on the form of pictorial art, with the exception of oriental art. In new pictorial forms the concept of a third stage of consciousness which is aperspective or free from perspective is being adopted. The decisive factor in this formulation is not the spatio-physical relatedness adjusted to a single point of departure, but an inner arrangement of things according to their content of form and expressiveness; function and symbolic significance. Jean Gebser investigates, in his *Origin and Presence*, the cultural-historical and artistic revolution of our time. It is not only the *natural* which corresponds to our ordinary methods of perception, and it therefore seems less important to create things *according to* nature than to create them *like* nature.

The graphic techniques in particular can help to bring about a more emotional view of things and a transformation of the merely visible, especially those techniques which employ the simplest materials.

Let the painter paint that which he sees in himself. Should he see nothing in himself, let him forbear from painting that which he sees before him.
Caspar David Friedrich

Plant study from nature.

Ink techniques

I let characters drop down on to paper. From afar one might well believe that they were plum blossoms which had fallen on a blanket of snow. The scent of mandarins disappears when a woman carries them for too long in the lining of her sleeve, but the characters which I drop on to paper will never ever disappear.
Li Tai-pe

Apart from the starting points for graphic work which have just been discussed, a separate section must be devoted to a material which is used extensively in drawing and the introductory graphic techniques—ink. Most graphic techniques are almost inconceivable without some form of ink sketch, whether for relief prints (lino and woodcuts), intaglio prints (etchings and engravings) or surface prints (lithography). Experimenting with this versatile medium is relaxing and inspiring, and will create the wish to reproduce graphic studies and designs, that is to print within the scope of the graphic techniques. We will find out more about this in the chapter on 'Introductory graphic techniques', p. 34.

Lithography offers the greatest range of possibilities for the manual reproduction of ink drawings and their special effects, but specific techniques can be achieved with various relief and intaglio printing methods. Obviously ink dots and strokes have a much more contrasting and lively effect in graphic work than dots and strokes made with a pencil. Corrections are, of course, more difficult, but this helps to define the artist's statement and leads to greater concentration. Ink is a marvellous material and has been used by artists from the earliest times; yet it always permits new discoveries to be made. It is not without reason that the words of the greatest Chinese poet, Li Tai-pe (698–792), introduce this chapter, alongside a Chinese woodcut offering 'Instructions on the use of the brush'. The old oriental masters of the ink drawing, who regarded writing, drawing and painting as a unity, understood the language of their material to an outstanding degree. We can always learn something new from Eastern art, but at the same time we must set out on our own voyage of discovery.

In the following pages of this chapter technical experiments with ink will be shown; the principles, tools and their application are many and various. With no claim to comprehensiveness, it is hoped that they will inspire you to make your own experiments. All artistic acts, even in their very beginnings, represent a discovery, an untiring creation and the adjustment of opposites and tensions.

Chinese woodcut: instructions on use of the brush.

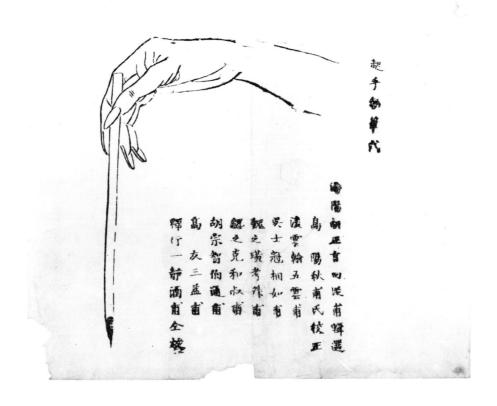

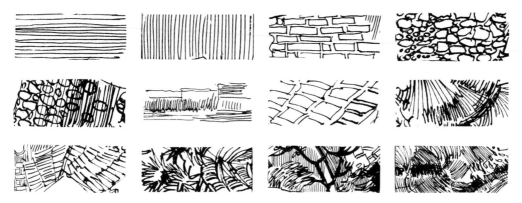

Experiments with drawing and writing pens; alternate vertical and parallel lines, ordered and disarranged, patterns, structures, textures. Contrasts of tone and direction were created by sectional division and variations in the density and thickness of the lines.

Below: Three exercises in different types of hand drawing: picturesque dotting, plastically moving and two-dimensional ornamental lines show details of pictures at half the original size.

This landscape sketch is mainly restricted to lines.

Bluebeard Max Slevogt.

Shader and reed pen A shader dipped in ink creates soft lines and borders, whereas strokes of a reed pen result in strong, sharp lines.

Brush On a rough surface soft borders can be created with the stroke of a reed pen or brush, and grey, screen-like tones by dragging them across the paper. A similar effect can be achieved by dabbing the brush on smooth paper; thinned ink resembles a water-colour grey.

Brush Using thinned ink (grey) and unthinned ink (black) alternately, and intermingling them is a way of creating sketch-like, picturesque improvisations.

On a damp surface The stroke of the pen on a damp surface results in mysterious, surprising shapes similar to frost flowers on a window. The stroke 'blossoms out'. Below—contrasting shapes with soft and hard borders.

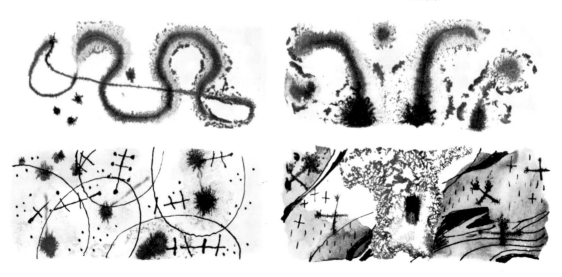

Pen-and-wash drawing This employs the same
technical means as just outlined, a sketch-like
combination of graphic and pictorial means.
There is room for picturesque improvisations.

Spray painting Screened surfaces of varying density.

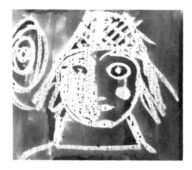

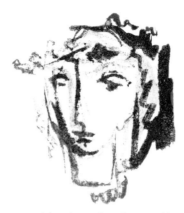

Ink on wax A wax drawing painted over with thinned ink.

A head on a heavily waxed background.

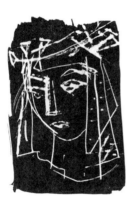

Scraperboard White marks (lines, dots, areas) can be scraped out with a knife or a lino cutter.

Resist drawing When it is dry, a white tempera drawing on paper will crack in places where ink has been painted on it.

Introductory graphic techniques

A painter's studio must be a laboratory. The painter does not pursue some mimicking craft, he invents.
Picasso

Potato prints and linocuts used to be the only hand print-making techniques practised in art lessons. Although it is not possible to carry out all graphic techniques in school, despite their tremendous importance for art education, certain preparatory exercises can usefully be undertaken. They cannot, however, be regarded as graphic processes in the strictest sense, since they lack the quality of reproduction; on the other hand, they are not pure drawings either. The exercises which fall into the category between drawings and graphic processes are particularly significant, and I shall call them introductory graphic stages or introductory graphic techniques. They reveal many hitherto unexploited possibilities which do not require specialized materials and can be practised by the layman, at the same time providing something new for the expert. The exercises in this category broaden the technical and formal aspects of drawing and provide inspiration for translation into a graphic medium. They also stimulate the student's imagination, helping him to relax and form a style of his own. They offer him pictorial effects which could never be achieved by a mere drawing. The following methods all belong to this group:

1. Montage, collage with different types of paper (cut, torn, also in combination with drawing or printing on glass, e.g. transparent paper or foil, photomontage).
2. Spray painting.
3. Transparent paper cut-out techniques.
4. Negative techniques (resist drawing, ink and wax crayon drawings, batik with paper or material, sgraffito work in wax, scraper techniques on coated cardboard, varnish work).
5. Monoprints from inked glass plates (direct and indirect prints).
6. Monoprints from painted plates of identical or different materials.
7. Paper stencil prints, silhouettes, prints from silhouettes.
8. Material prints (direct and indirect prints).
9. String prints.
10. Photograms (from materials, engraved or painted glass plates).

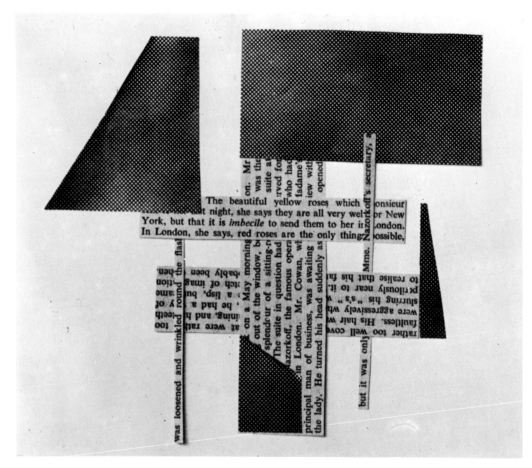

Collage.

These ten introductory graphic techniques will be described individually in the following sections, as they present a useful preparatory training for the actual picture printing processes, as well as being valuable in their own right. The last four could, in fact, be classed as 'real' graphic techniques, if they achieve the possibility of reproduction. The main part of this book deals with the graphic techniques in the stricter sense (autographic processes: relief, intaglio and surface printing).

Montage, collage, etc.

The simplest montage effects can be achieved by using black paper on white, and vice versa. Strips of paper can be built up into fantastic constructions, positive and negative; they can be combined, their shapes can be enlarged by the addition of rectangles, circles and triangles, or mixed with other more distinctive shapes. It is surprising how balance and relationships can be achieved in exciting succession by arranging and adjusting individual shapes. The ease with which such a detached composition can be altered offers a whole series of possibilities to the critical eye within a very short space of time. The most harmonious arrangement can be chosen. The work resembles that of a window dresser or a photographer, both of whom are dependent on the stocks at their disposal and only have to place them in the best position. The photomontage, already much used by the surrealists (particularly Max Ernst), also belongs in this category. After each completed stage of the composition, and at the end, it is advisable to place a glass plate over the paper shapes arranged on the background in order to prevent the paper from being crumpled or damaged. Once the picture is visually satisfactory, it can be stuck down. Torn instead of cut pieces of paper can also be used in a montage, and other materials such as scraps of cloth, etc., can be introduced; this results in a more pictorial effect.

Photomontage.

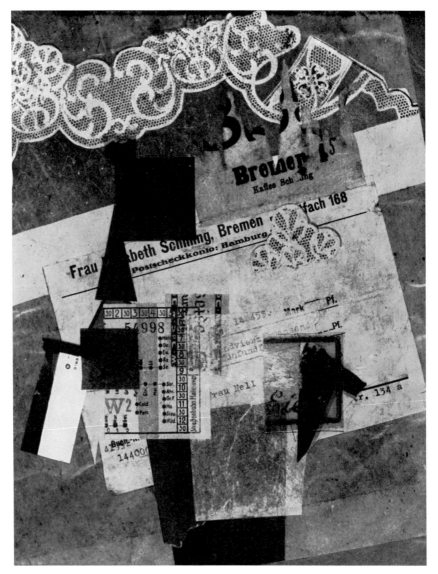

MERZ picture 233 Kurt Schwitters. Owned by Jan
Tschichold, Basle.

Kurt Schwitters assembled his 'Merz pictures'—so called after the fragment of the word *Commerz* on one of his collages—from objects of very differing natures (bus tickets, newspaper cuttings, scraps of paper and cloth, lace, wood veneers, etc.).

The illustration on page 36 is a photomontage done by a schoolboy. Portions of pictures were cut out of illustrated magazines and put together to create an image in which the original objects are rendered valueless and subservient to a constructional and ornamental rhythm. It is an example of a contemporary view of nature which overcomes the perspective arrangement around a line of sight and the perception of planes in favour of a rhythmic arrangement which is aperspective. See also the collage on page 35.

Spray painting

In the illustration on page 32 strips of paper cut out from pieces previously sprayed with drawing ink were used. The spraying can be carried out either by using a mouth spray tube or by drawing a toothbrush or a bristle brush dipped in ink across a wire sieve, that is if proper spraying equipment, with nozzles and carbonic acid containers, is not available. The fine black rain of ink colours the paper grey and increasingly darker; masked areas remain white. Repositioning of the stencils results, on respraying, in new grey tones as well as additional shades and the deepening of other existing tone values. Cut-outs placed close to the background give rise to clearly defined edges, whereas a more blurred effect on the sprayed surface will occur if the cut-outs protrude.

The spray painting illustrated here was inspired by a Feininger exhibition; a student developed an imaginative impression of space by overlapping cut-outs.

Transparent paper cut-out techniques

Both montage and spray techniques usually employ cut-out paper shapes. We shall now look at transparent paper cut-outs, which can be cut into shape and folded in such a way as to create surprising 'dislodged' effects and reflections of different tonal areas. Simple geometric shapes (triangles, rectangles, semicircles, etc.) are cut with a scalpel or razor blade from a sheet of transparent paper placed on a glass plate, leaving one small part of each of the shapes uncut. The shapes are then folded over from the uncut part, so that each one appears as both a hole and a double thickness of paper.

If a second sheet of transparent paper or a plate of frosted glass is placed over it and the whole construction is held up against the light, it resembles a glass etching and could, in fact, be used as a sketch for one. The effect can be varied by incorporating string or coloured transparent paper. Contrast of tonal areas in transparent paper cut-outs and spray paintings provides an inspiring introduction to the techniques of aquatint, lithography and screen printing, which will be described later.

A folded transparent paper cut. The half sections
are cut and folded over.

The still life illustrated in the picture above shows the bright effect of the cut-out
parts of the picture and the darker mirror image where the pieces of transparent paper
were folded. New shapes and surfaces arise through several overlaps, with rich differences
of tonal value. The original was approximately one metre wide. It was placed between
two large plates of glass, one of which was frosted. The latter was then hung beneath
a light, which shone through it allowing the full range of transparent effects to be
realized.

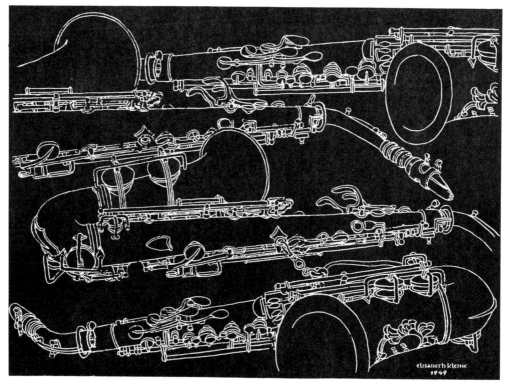

A resist drawing.

Negative techniques

This is a collective name for various techniques in which lines and flecks, generally dark against a light ground, are reversed to appear as light against dark, negative instead of positive.

The simplest way to produce white lines and flecks on a black ground is, of course, by means of a coat of opaque white paint on a black ground. The way in which the white lines and surfaces are technically achieved is, however, not immaterial to the

artistic effect. I still remember the special visual sensation which I experienced when playfully blackening a plate with a candle and then scraping out white lines and surfaces with my fingers and a brush handle—my first negative technique. There are many other examples of this kind. Some of those which are of special importance for the autographic processes are described here. Each of the negative techniques treated in this section provides us with rather special visual effects which are fundamentally different from those of other techniques and strike one as more delicate and highly individual, especially when compared with images achieved by simple coats of white paint. For this reason each of the six negative techniques and their individual variations will be discussed separately.

Resist drawing

This is the name given to the technique in which different paints and inks are applied on top of each other, separating on contact. This happens, for example, when drawing ink is painted on top of opaque white or tempera colour. If you apply opaque white lines with a writing or drawing pen on paper and then paint black ink over the whole

Pen and brush strokes in a resist drawing.

surface, the black ink will remain firm in those places where it is in direct contact with the paper. In places where there are white painted lines underneath cracks will soon form, and the dark coat disintegrates and detaches itself. Brushing and washing will speed up the process. The result is a white line drawing similar to a lino or rubber cut or to a relief printed line etching. Resist drawing differs from these two techniques in having weaker, torn edges and a dark, almost vibrating colour tone which loses some of its depth and regularity when the picture is brushed, and even more when it is washed off. This method has great potential and can be varied by using previously drawn or written on sheets of paper; visually attractive pictures with surprising effects can result.

In order to detect inherent regularities and to collect varied experiences, it is a good idea to begin by experimenting on rough paper. Such playful use of techniques will prove rewarding and inspiring.

Experimenting with material can become even more interesting if the white is not applied with linear pen strokes but with a bristle brush, covering the paper with a partly opaque and partly translucent coat of paint. Additional effects can be achieved by gently guiding the brush across the paper so that it only touches the background lightly. These alternative methods will produce a wide range of optical effects. The illustration on page 44 is an example of a resist drawing using the brush method, as compared to the linear technique of the picture with the saxophones on page 41. In the former the use of textures (for example in the curtain and under the chair) strangely animates the picture. A small technical trick may be revealed: a piece of net curtaining was dipped in white paint and an impression of it was then taken on the white paper. After painting the paper with black drawing ink, allowing it to dry and then washing it, the paper revealed this textural effect, showing up the un-inked parts of the paper beneath.

There is an unlimited number of combinations. The possibilities should be investigated, recognized and should later on be consciously used. By having to reduce the illustrations, many of the more delicate graphic effects have been lost. Further variations can be achieved by making white drawings on packing paper or coloured paper first, or by the use of tempera colours for the basic drawing.

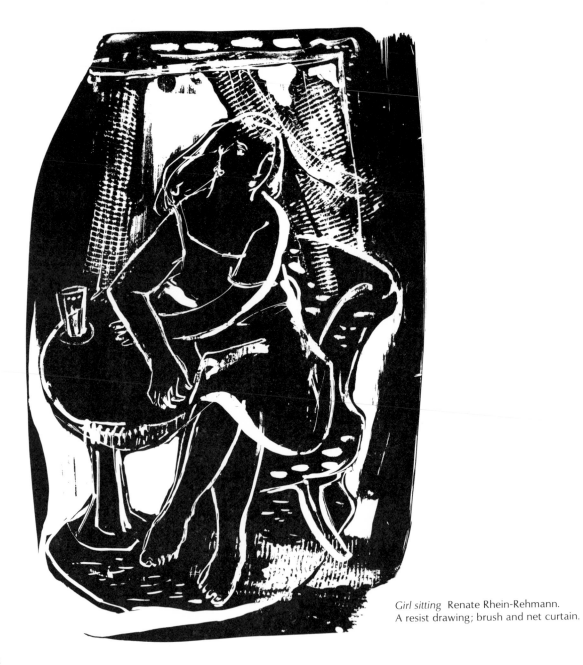

Girl sitting Renate Rhein-Rehmann.
A resist drawing; brush and net curtain.

44

Wax resist drawings, paper batik

This and the next section deal with methods based on the resistant effects of wax and water-soluble paints.

Lines drawn on white paper with a wax or stearin candle are resistant to water paints or inks applied later. Rough white surfaces edged with droplets remain, and these could not be achieved without a wax coating (see the illustration on page 33). The effect is similar to that of a negative drawing in lithography, where scarcely visible lines and flecks are made on the stone with gum arabic instead of wax and coated when dry with lithographic ink (see the illustration on page 167). Further treatment of the stone causes the gum arabic, as in the case of resist drawing, to break through the coat of lithographic ink, and these areas remain white when printed. A similar technique can be used for etchings. Wax drawing as a base and the resist technique are closely related introductory graphic techniques. Still closer is the relationship between wax resist drawings on paper, known as 'paper batik', and wax printing on textiles, for which the term 'batik' is generally used.

Wax printing on fabric, batik

If we draw on cloth (instead of paper) with melted wax and dip it into a bath of fabric dye dissolved in water, we are dealing with wax resist work or batik. Batik originated in Java, where it is a much practised method of dyeing textiles in a variety of patterns. The parts to remain light are coated with wax, as they resist the dye. After dyeing, the wax is removed by boiling or ironing the cloth, or by washing it in benzine or trichlorethyl. Successive waxing and dyeing results in colourful, artistic patterns which are enhanced if the coat of wax is hardened in cold water and broken. The dye penetrates the cracks in the wax and produces those colourful lines typical of batik.

Fabric dyes may be used for this method, or natural dyes from boiled onion skins, etc.

Before each new waxing the material must be dried. It is best to apply the wax coat with the fabric on a layer of newspaper, or to stretch the cloth across a frame. Cotton, silks and linens are the most suitable fabrics for batik; the wax is applied with bristle brushes, tjantings (wax pens) or copper stamps. A separate vessel should be used for each dye colour, and the dressing must be washed out of new materials before waxing.

Batik with stamps. Gisela Hein.

Sgraffito

If a strong piece of drawing paper is covered with black wax, a negative image can easily be created by scratching white lines and areas into the drawing surface with a knife, needle or scalpel. The scratched white sections will look even neater if the paper is covered evenly with white wax crayons before the coat of black wax is applied. Drawings scraped or scratched in this way look very similar to those created from commercially produced scraperboard, which requires the same type of scratch and scrape technique and will be described in the next section. The two techniques are strongly related.

The different grey tones in the illustration on page 48 show clearly that the layer of white wax underneath did not quite reach the upper and lower edges.

If certain sections of the picture are painted with watercolour or tempera before it is sealed with black wax, alternate white and coloured lines will be revealed on scraping away the coat of wax. Instead of watercolour or tempera, wax crayons can also be used to colour various sections white, yellow, red or blue. Further variations can be achieved by overpainting these latter sections with a different crayon colour, which will result in strange colour mixtures. When the wax is scraped away, colourful lines and surfaces are revealed, in which you can trace colour effects and their contrasting qualities; multicoloured compositions make an interesting subject for study, as contrasting elements of colour and quantity can either be balanced by a further layer of wax crayon or by further scraping away of the black wax coating.

Exciting effects can be achieved in this way. Chance does play a certain part, as it is difficult to anticipate during the process of scraping away the wax which colour will be revealed next and what its effect on the development of the whole composition will be. However, tentative experiments can serve as a stimulus for preparatory sketches for coloured graphic work. With careful planning, effects similar to real sgraffito (plaster decorated with a scratch-work design) can be achieved. This technique of surface treatment is, from the formal point of view, closely linked to coloured graphics.

Sailing Boats Sgraffito work in wax.

Scraperboard

The scraperboard technique should not be confused with mezzotint—also a scraper technique—which is an intaglio printmaking process, and which will be discussed in the chapter on etching. Scraperboard consists of strong cardboard covered firstly with a layer of very fine white pipe-clay and then with a thin layer of matt black ink. When the black surface is scraped with a needle, a fine knife or some other special tool, the white layer beneath is revealed. With a little effort the finest negative drawings can be achieved, and these approach the effect of a subtle end-grain cut.

In the section on ink techniques reference has already been made to the scraperboard technique. As this technique offers a great number of possibilities for graphic design—long realized in countries such as France, England, the USA and Austria—it really deserves more space than can be devoted to it in this book. Friends of mine still buy their scraperboards in Paris, and sophisticated screened and embossed scraperboards are available in America, England and Austria.

The most intricate filigree work can be executed in the smallest of formats without great difficulty. Blocks made from such drawings are a way round the lengthy procedures involved in wood and end-grain cuts. It is usually not possible to achieve the same precision working on home-made scraperboard as on commercially produced materials. Scraperboards with smooth black or white surfaces can be obtained in all art shops. Black boards can be scraped with a design directly; those with a white surface, however, have to be painted with black or coloured ink beforehand. Nevertheless, white boards are usually preferable. Scraperboards are available with a wide variety of surface textures, embossed lines, square and diagonal hatchings, or grained. The last six of the nine squares illustrated on page 51 and the two small rectangles on page 52 were created from boards which were originally plain white and subsequently treated.

In figures 1 and 2 on page 51, lines were scraped out of black-coated scraperboard (they could have been made with an etching needle, scalpel, the point of a pair of compasses, or a knife). In figure 3 white areas scraped out with a razor blade were added to the lined surface. Into the largest of the white spheres four black concentric circles were drawn in with a drawing pen. They would have been smoother and more

precise if the white spheres had not been inked over when the board was blackened initially, and it would then have been unnecessary to scrape them out.

For figure 4 the blackened scraperboard was covered with sandpaper and put through a proofing press in order to obtain a grainy texture on which further designs could be scraped out. In figure 5, in order to achieve another textural effect, a piece of net was dipped in black ink and an impression of it was taken on the white surface of the board. An interesting background was provided, against which scraping could be carried out. For figure 6 the entire white surface of the board was coated with thinned, grey ink instead of black. Lighter sections were removed with a razor blade and black squiggles and dots were added with a pen.

The last three figures and the top left-hand illustration on the following page were inspired by works of English and Austrian scraperboard artists illustrated in the book *Scraperboard Drawing* by Bacon. Only plain black and white scraperboards were available and so the students developed their own techniques on the theme. An excellent substitute for specially prepared boards was achieved by putting a plain black inked scraperboard through the fluted rollers of a copperplate printing press. Areas and lines scraped out of it revealed a horizontal pattern of lines which can be seen in the illustration on page 52. In England, Austria and America special types of scraperboard with a variety of textures, screens and hatching are produced commercially. With this specially prepared material picturesque effects can easily be achieved by allowing for the basic pattern of the board and taking the screened, hatched or embossed qualities into consideration when scraping the design.

We discovered a further substitute procedure when we put a board through the fluted rollers of a press twice in different directions (resulting in the rhomboid textures in figure 7 and the squared hatching in figures 8 and 9).

Figure 4 has a sand grain texture, which was achieved by pressing sandpaper on to the board. Certain sections of the top right-hand illustration on page 52 show a similar effect, but in this case it was achieved by the use of a roulette and a moulette. Both are really engraving tools and consist of either a ball, a wheel or a roller with tiny sharp teeth which leave marks on the surface similar to the grainy quality of chalk. (See the chapter on etching and engraving, especially the section on soft-ground etching.) To a certain extent this illustration resembles the characteristic effects of the mezzotint technique, which will be described more fully on page 138.

1 - 3

4 - 6

7 - 9

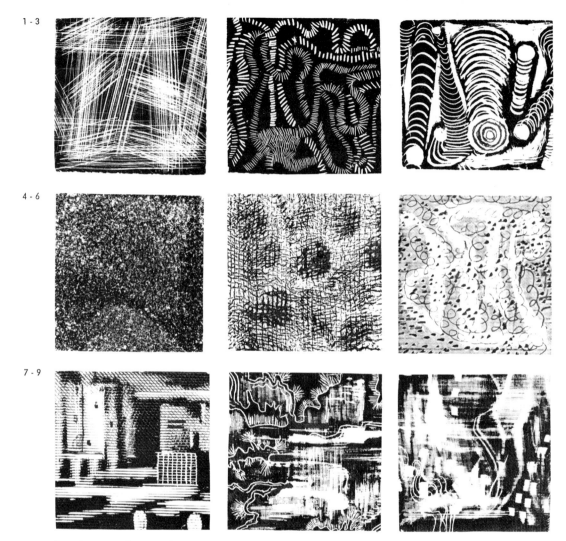

Experiments with scraperboard.

Experiments with scraperboard.

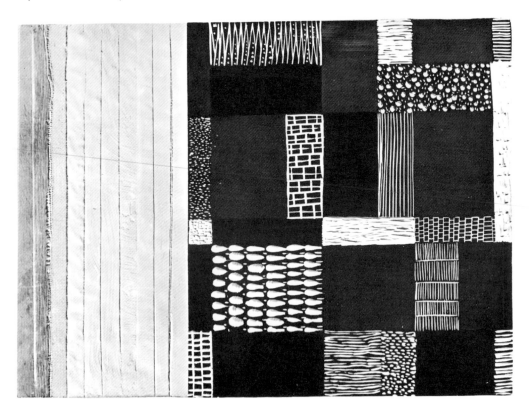

Varnish work.

Varnish work

As preparation for this work, a piece of linen is mounted with skin glue on to a well-dried block of wood. The cloth is then painted with four or five successive coats of chalk, the first coats being dabbed on or painted with a rotating brush, and the last being applied with regular brush strokes. After the surface has been smoothed out, polished and sealed with very thin glue, one or two coats of varnish suitable for cutting are applied (depending on the shade required). Any areas to appear matt are treated with an abrasive; parts to remain shiny are masked with protective paper.

The parts of the design to appear light are cut out with lino cutters or knives in a similar manner to wood or linocuts. These two latter methods are specifically related to varnish work, the chief difference being that the finished wood or lino block is only an intermediate stage, a means to an end (which is the printing of the image on paper), whereas a varnish block is itself the end result. In the example illustrated here seven chalk layers were applied to the cloth, which was glued on to a strong block of wood. Apart from the carved lines, effective contrasts were produced by the alternation of matt and shiny surfaces.

Monoprints from inked glass plates

Direct and indirect prints

A monoprint is simply a *single print*. In the technique to be described here, a glass plate is rolled with printer's ink, placed in a vertical position and covered with a sheet of tissue which should be glued lightly to the top or the back of the plate. If the tissue paper is then pressed firmly against the inked glass plate with whatever objects are handy, traces will appear on the back of the paper (figure 1, page 54). In figure 2 on page 55 a schoolboy who had made a mess of his first monoprint furiously put the full

1

weight of his hand on the next glass plate, and the result was this involuntary monoprint. Figure 3 on page 55 was also a chance result. The plate was too thickly coated, and the student could not make a drawing on the back of the paper because it was stuck to the inked glass plate. She was about to throw it away, but I pointed out that the chance marks showed an attractive graphic design with rhythmic and tonal qualities.

The usual method for monoprints is, of course, quite different. With a brush handle or pencil a drawing is made on the back of the paper, and the lines thus produced are pressed against the inked glass plate to leave an impression—the drawing—on

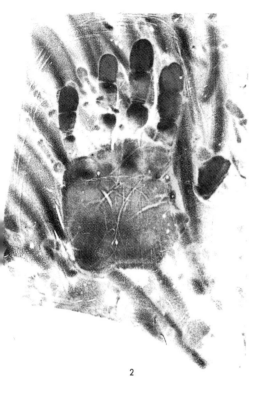

2

3

1. A drawing monoprint.
2. Impression of a child's hand.
3. Graphic, picturesque chance effects.

the front of the paper. Tonal effects can be added to a linear drawing by, for example, pressing the paper down with your hand or by incorporating chance effects of the type mentioned in the previous paragraph. Traces produced by the pressure of the hand will be clearly visible on the back of the paper and their soft outlines give a lively, intense quality very different in character from a pen or pencil line. Monoprints cannot be corrected, but this can be rewarding, as it leads to greater concentration. The movements of the hand must remain flexible, but the hand itself should never rest on the working surface. Unintentional effects within the design are sometimes worth exploiting, however.

a

b

c

d

Monoprint taken from the smooth, plane surface of a plank anvil. The lines drawn with a pointed rod are black lines (a, b). The white lines on the dark ground have remained on the surface of the anvil and are carefully rubbed on to another sheet of paper (c).

e

f

g

h

Black areas can only be applied in certain parts, i.e. rubbed down with a finger (d, e). Impressed letter shapes from a printing set (f). Sectional removal of the pigment from the surface of the anvil before printing (g, h). Details drawn in on the remaining shape (h).

A combination of direct and indirect printing can be achieved in the following way. We might find on completion of a monoprint created by the method just described—indirectly so to speak—that the coated glass plate shows up a negative impression of a previous drawing in the form of white lines. If a sheet of slightly dampened paper is placed over the wet ink and rubbed very carefully all over the glass by hand or with a rubber, the back of the paper will reveal a negative version of the original positive print, with white lines on a dark background. Such a monoprint can, of course, be developed even further by printing a positive impression on top of it. This is done in the usual way by making a design on the sheet of paper attached to the inked glass plate. The new monoprint will show up darker lines in addition to the white lines against the grey surfaces of the dark background.

The term frottage is applied to the technique in which low relief objects or plastic letters are transferred to a sheet of paper by rubbing a lead pencil over them and causing an image to appear on the paper. This is the normal method used for making rubbings of decorative ornamentation on monuments. (See the illustration on page 216.)

Monoprints from painted plates

A variety of materials, but especially metal plates, linoleum, sheets of plexiglass, press-board and waxed shiny cardboard are suitable for retaining printing inks or oils which can then be transferred to a sheet of paper by means of a printing press. For small items the frottage technique described above can be employed satisfactorily, using a rubber, a paper folder or an ordinary spoon. Place the thumb of your right hand in the bowl of the spoon and rub it over the paper, which should be placed on top of the inked block. In this way the design will be transferred to the paper. If the bowl of the spoon is moistened with damp soap it will move more smoothly. To protect the paper to be printed on, a second, plain sheet can be placed over it; this will take up the rubbing marks of the spoon. In this form of monoprint the picture is painted directly on to a non-absorbent surface and then transferred (i.e. rubbed) on to the paper as a reversed image. Even the first attempts will show surprising results, as the pressure creates a close relationship between ink and paper. Individual colour effects can be monoprinted first and then overprinted by a monoprint of an outline drawing;

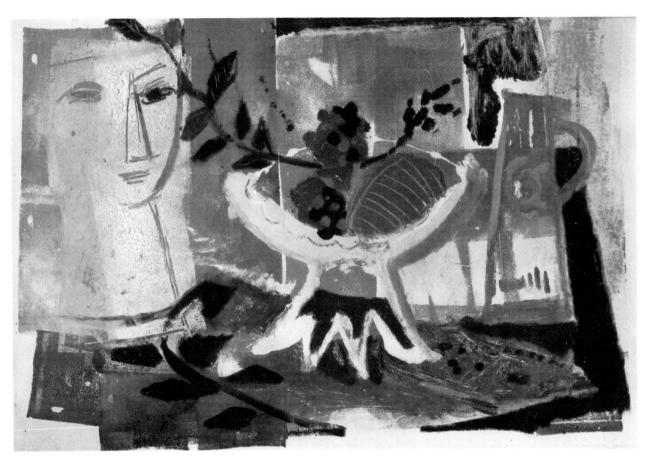

Still Life Renate Rhein-Rehmann. A colour
monoprint created by overprinting.

this does not need to be in register with the first print and will therefore not look like a coloured, but a painted picture. Outlines of objects and forms will not overlap, but will run into each other. Painting is not a matter of colouring shapes, but rather of shaping colours!

This technique is closely related to painting and leads to many new discoveries. One can even print from a lino block painted for the purpose; the result is an interlocking grid of a white linear pattern with a series of coloured surfaces (see the illustration on page 73). Only the linear pattern had been cut into the lino block, which was then painted. The whole colour print was made from just this one block.

Impressions taken from etched plates painted with oil or printer's ink on to absorbent paper result in delicate lines and surfaces with a watercolour quality.

Stencil prints

Stencils cut from strong paper or cardboard with scissors (or with a sharp penknife on a sheet of glass) are coated with printing ink and printed on paper either by means of a copperplate printing press (see page 61) or by the frottage method as in the case of a direct monoprint.

If you print from a faintly inked stencil, the impression will turn out grey. Now, using the same paper, the stencil can be printed again, but this time placed in a slightly different position. If this process is repeated a number of times a series of prints can be built up with varying grey values and tonal strength, which can be achieved by either adding or masking portions of the print. You can also introduce a further colour if you wish. The stencil print *Trees* (illustrated on page 61) was created in this way.

Stencil printing can be carried out with the simplest of shapes, since the effect achieved depends more on the changes made during each printing stage than on the design of the stencil itself. Its ornamental effect is used in textile design, fabric printing, wallpaper design and commercial art.

Prints from cardboard.

Trees A two-colour print from paper stencils.

Printing from different materials (material prints)

Direct printing

Finding a suitable medium to be used as a block for material printing is even easier than the production of stencil prints. Any piece of material that will readily accept a layer of ink from a printing roller can be used, regardless of whether it is a natural product or man-made. The piece of material is coated with printing ink and then printed. The structural details of a print from a piece of wood can often be most surprising. Subtle patterns can be built up on paper with lattice-work tulle, sacking and net curtain. Graphic effects can be created by the introduction of inked string, thin wire or corrugated paper. The final picture is built up from a series of prints. From the graphic point of view, the best results are usually achieved by overprinting.

Indirect printing

In mechanical graphic reproduction, offset printing is considered to be an indirect printing method, since the plate carrying the image first transfers the image to a rubber-blanketed cylinder, which then transfers it on to the paper. By means of an intermediate method it is possible to develop from a direct material print (as described in the previous section) an indirect impression not unlike that produced by the complex workings of an offset printing machine.

In the previous section on direct printing methods it was shown that various objects can be coated with ink and printed directly on to paper. The rolling-up is done with a relatively solid gelatine roller. An ink deposit of the coated object is retained on the roller. This discovery resulted in the following experiment: the inked roller was rolled over a lime leaf which had been sprinkled with cigarette ash. The roller was only allowed to rotate once before being rolled over a piece of smooth white cardboard once from top to bottom. In this way the image from the lime leaf was transferred

Print from a sponge darkened in sections.

from the roller to the cardboard. The scattered white dots were caused by the cigarette ash sticking to the roller and preventing the ink from being passed on to the cardboard.

Fascinating effects can result from rolling a well-charged ink-roller once over a flat piece of material such as a net curtain and then transferring the impression to a smooth piece of white cardboard. Shapes and traces of the curtain are reproduced in the rectangular passage of the roller. This indirect method of printmaking is capable of surprising even the experts.

A double print with corrugated paper. Corrugated paper glued to a firm base allows a number of impressions as long as the rubbing of the print is executed by hand.

64

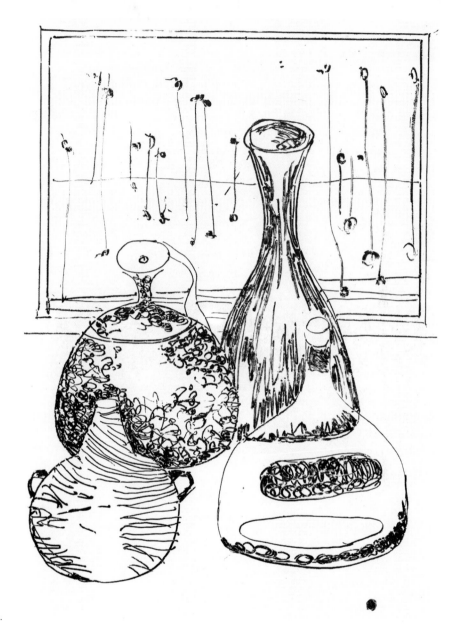

Cliché verre.

String prints

String prints are closely related to material prints. Strong string of any thickness is glued on to pasteboard. In order to suit the nature of string, a linear outline based on a continuous line is best. The string block is inked up with a roller and the impression is transferred to paper either by employing the frottage method or mechanically, using a printing press.

A photogram in which successive stencils were employed during exposure of the light-sensitive paper. Rolf Hartung

A string print.

Photograms

We are dealing here with photograms from materials and from engraved or painted glass plates.

Direct prints from inked-up objects are not far removed from the photograms from which photography developed. Materials such as scraps of paper, leaves, blades of grass, etc., are placed on light-sensitive paper, exposed to the light, and then developed. Commercial artists frequently employ such methods. The photogram opens up an interesting field for experimentation.

If, instead of working directly from materials, we make a drawing or a chiaroscuro on a glass or plastic plate, a copy on light-sensitive paper will result in an image in which the original light and dark parts are reversed. A 'cliché verre' or glass engraving is made by engraving a glass plate coated with collodium, thin oil paint, graphite or any other transparent material and transferring the image on to photographic paper by exposing it to light. Corot was one of the first to employ this technique. It is possible, of course, to combine the two methods by first painting or colouring the glass and then scraping points, lines and sections out again, and finally transferring the image on the glass plate on to light-sensitive paper.

A summary of the introductory graphic techniques

All the preliminary graphic techniques and their countless variations listed here are not graphic techniques in the strictest sense. These will be discussed in the next chapter. On the other hand, they should not be regarded simply as introductory exercises, but should also be appreciated for their intrinsic value. There is no absolute formula or strict sequence in which they should be used. It is best to start with the technique in which you are most interested and for which you happen to have the necessary tools and materials. One can establish that the first five techniques are more closely related to drawing and the last five to the real graphic techniques. All of them, however, form an excellent basis for the work involved in the graphic techniques to be outlined later. They can also be drawn on as a technical aid for translating individual ways of expression into a graphic language. After having experimented with a number of methods, the student will be in a position to pick the one most suitable for carrying out a particular task.

Paris spariispar
rispaar ispparis
ipars rspi aispr
parisasarip ipar

Hand prints with simple letter shapes.

le
ele
elen
helen
helena
neleh
nele
ele
el

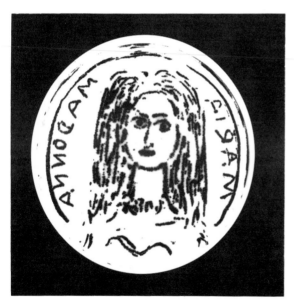

A glass engraving; collotype on light-sensitive paper.

Methods of reproduction

May God bless copper, burin, pen and all the tools of reproduction, so that good things, once in existence, may be saved from oblivion by countless images.
Goethe

I. Relief printing

In relief printing it is the raised parts of the printing block which receive the printing ink—usually from a roller pushed over the surface—and which then transfer it to paper by means of pressure.

Potato prints

The equipment needed for this method is very modest; a couple of potatoes, a penknife, a paintbox, a brush and drawing paper are all that is required. A block can easily be carved from a potato cut in half, and this can then be painted with watercolour, tempera or ink and used for printmaking. At the beginning one should stick to simple shapes and a single colour. When joining up the impressions into a decorative pattern, the negative parts of the block should also be taken into consideration; it is a good idea to vary the arrangement by introducing a different shape. A composition can be built up by arranging identical shapes in rows in which they are repeated regularly, reversed or displaced, or by altering the image by shifting the centre point or creating scattered effects. In this way rhythmically moving groups can be built up on the paper which can either be symmetrical or asymmetrical and give way to free arrangement (moving towards and away from each other, dislodged, partially covering each other or whirling around, etc.). The straightforward potato cut has great potential and can also be used in conjunction with line drawings or pre-painted surface areas. It is a suitable medium for textile design, wallpapers and book covers. Decorative possibilities are multiplied if different colours are introduced. Commercial artists frequently use potato cuts in conjunction with lino or rubber cuts as an inexpensive method of creating colourful effects.

A potato print in which the natural shape of the
potato is exploited in the design of the cut.

Linocuts

Technical materials

The most common graphic technique practised in schools is the linocut. Cheap offcuts
can be obtained from any linoleum store. Smooth, relatively thick linoleum without
a pattern is best. If the linocut is intended for machine printing, it is glued to a board;
the board and the linoleum together should not exceed the required width of 23 mm
(1 in). Gouged shapes and lines are cut into the block with a lino cutter, a knife or a
hollow chisel. It is a good idea to cut the outlines into the linoleum first. Provisional
proofs can be made by rubbing the lino block with a spoon or a paper folder. If you
are already familiar with the technical materials, a sketch of the design might be
more suitable. Good effects can be achieved by using any normal waterproof printing
ink. After experimenting with various types of line, it is advisable to make a sketch

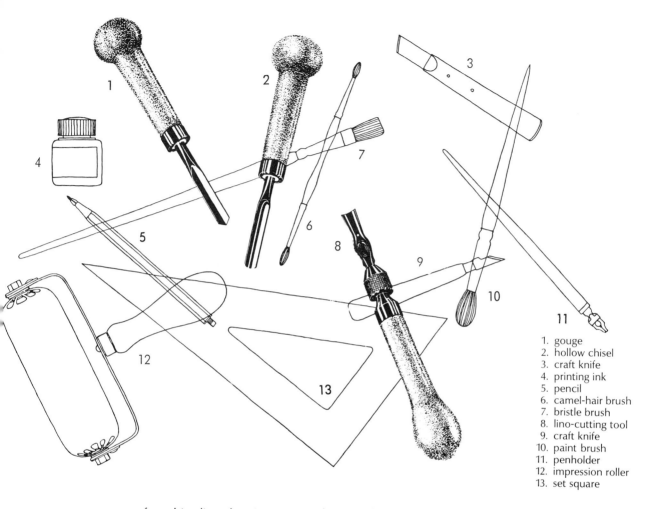

1. gouge
2. hollow chisel
3. craft knife
4. printing ink
5. pencil
6. camel-hair brush
7. bristle brush
8. lino-cutting tool
9. craft knife
10. paint brush
11. penholder
12. impression roller
13. set square

of a white-line drawing, as any line cut by a gouge, a hollow chisel or a 'V' tool will turn out white. For rolling-up with ink you will need a firm, flat surface, and for larger prints an old litho stone with a smooth top is best. Printing inks can be thinned with printing oil or turpentine. A spatula is helpful for achieving the right consistency, as the ink must be carefully mixed and evenly rolled up. Solid rubber rollers should be thoroughly cleaned after printing (in the case of oil-based inks, with turpentine substitute or roller-washing fluid).

Japanese paper is the most popular type for printing. An absorbent printing paper which is not too bulky should be used, and if water-soluble drawing inks are used for printing, the paper should be placed for approximately an hour between two sheets of slightly damp newspaper in order to increase its absorbency. If the rubbing method is employed for the printing process, on completion the paper should be carefully pulled back from one edge in order to check the impression and, if necessary, to replace the paper and continue rubbing. Since smooth blocks can only be achieved with very sharp tools, a whet- or oilstone should always be at hand.

More even prints, though of a less individual style than the rubbings, can be produced on a copying or so-called plant press. In this process a plate is lowered from above on to the printing surface. The pressure is controlled either by a lever arm or by screwing the upper on to the lower plate—a system rather like that of the old craftsmen's bookbinder presses. Other presses for relief and intaglio printing processes use rollers, and all three types can be printed on these; for surface printing, zinc plates would, of course, be used instead of stone. It goes without saying that great care must be taken with a press if it is to last for a long time (for example, by cleaning the steel rollers, the chase and the metal frame, by greasing, lubricating and covering up). If one uses a copperplate printing press for lino or soft wood-blocks, the process is similar to that of etching, with the difference that the plate is not warmed, the pressure of the steel rollers is set at a weaker level and, in place of the felt blanket used in relief printing, a smooth, firm cardboard sheet should be placed over the lino or wood-block.

Pictorial techniques

Particularly suitable subjects for design are white- and black-line cuts, silhouettes, black and white faults (a concept borrowed from geology), decorative patterns and tonal hatching. Linocuts are most suited to flat representations. Picturesque light and shade effects tend to look shapeless, and a naturalistic approach is not in keeping with the basic style of the linocut. The linocut demands transformation and translation. Decorative patterns cut into lino or wood-blocks can also be printed on smooth fabrics. Linocutting demands simple shapes and clear-cut contrasts.

After removal of the lines from the lino block, the impression of the drawing appears as a white-line cut.

Crossing lines enclose sections, some of which were cleared with a broad gouge, thus stressing the contrast between white and black areas.

Ring stamps printed laterally on top of each other. The stripes which were cut away fit in with the broad black lines. The V-stamp overprinted from all four sides is an integrated part of the web-like structure of black lines.

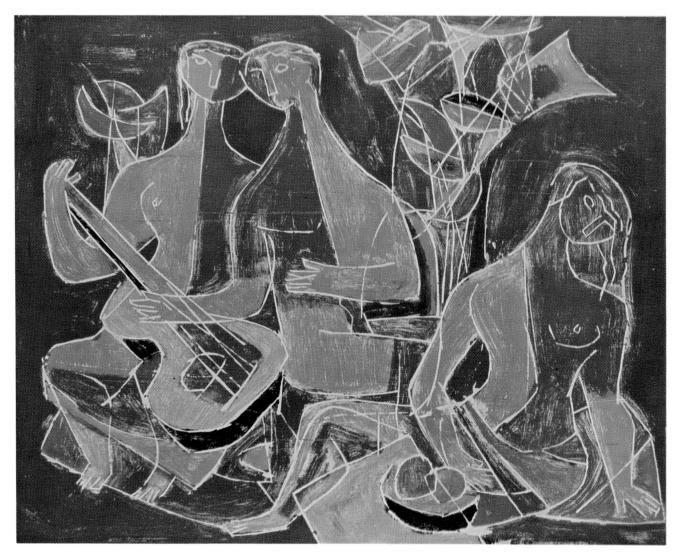

Peace Gerth Biese. Multicolour print from a lino block.

Woodcuts

Much of what applies to the linocut—e.g. the cutting tools used and the printing of the block—is also relevant to the woodcut.

But this highly individual material, which has its own distinct characteristics, requires much thought and special attention. For the block we generally use long-grain timber, and occasionally end-grain timber or even plywood. Long-grain timber is cut *with* the grain, and end-grain timber *across* the grain. End-grain timber is really only used when very fine effects are required, for which wood engraving (see the following section) is more suitable. It is also used when more than a thousand impressions are to be run off the same block, as timber cut across the grain is more resilient to pressure than wood cut plank-fashion. Depending on the particular type of wood and its hardness, long-grain timber puts a much greater strain on carving tools and chisels during the cutting of the block than the much softer linoleum. The organic structure of the wood, which is more or less prominently marked in different types of timber, makes certain carvings impossible and might force the chisel to follow a direction not previously planned. If the block is then only lightly inked, the printed impression will show up the grain of the wood most effectively. In some woodcuts this feeling for the natural structure of the wood has been incorporated into the basic design of the picture (see the illustrations on pages 76 and 77). A sculptor's wood-carving and a graphic artist's woodcut are very closely related. Khing, the master wood-carver,

says to Prince Lu at the end of the wonderful Chinese fable about a frame for a set of bells (in the *Speeches and Riddles of Chu-ang-tze*): 'I walked through the forest for several days, up and down the mountains, looking at the formation of the trees. In one tree I saw a frame for the bells. And had I never found that tree, I should never have been able to carve it'.

Almost every kind of wood can be used for woodcuts. Wood which is porous and soft with prominent fibration, such as pine and fir, can only be used in large planks and for simple designs. Lime and poplar wood have no pronounced structure and can be carved easily. Oak and nut are much harder and therefore more difficult to carve, but they are suitable for large editions of prints. Fruit wood is most suitable for long-grain cuts; pear wood is tough and of a consistent hardness, and results in an even strength of cut. Apple and cherry wood are softer and yield more to the cutting tool. For end-grain work, box is often chosen; it is harder than pear wood and usually

Capital K Julius Bissier. Woodcut.

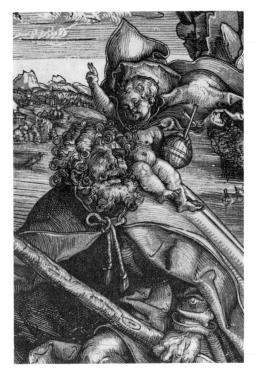 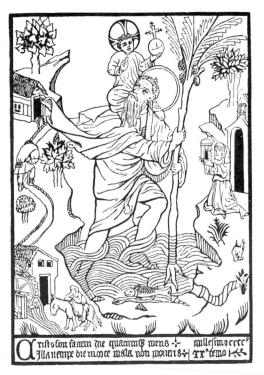

St Christopher Woodcuts.

made up of small pieces glued together—a precious and expensive material. When selecting wood, care should be taken to ensure that it is dry, has been stored well, and is generally free from knots and faults. For handprinting the thickness of the wood-block is of no importance, and any size between 12 and 25 mm (½ in–1 in) can be recommended. If the block is intended for machine printing, however, it must be exactly 23 mm (1 in) thick (it can be built or glued up if absolutely necessary), since this is the standard height of printing type to which all machines are geared.

Cutting tools

Cutting tools have already been mentioned and illustrated in the section on linocuts. During the carving process they quickly become blunt, but they should always be

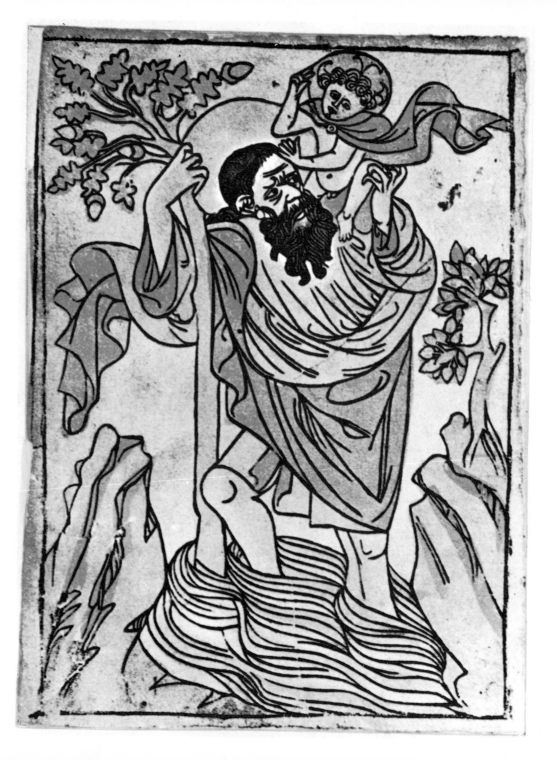

Woman in profile Emil Nolde.

sharp enough to cut through a hair held between the fingers. Frequent sharpening is therefore essential. This can be done on a whetstone—an oilstone which is moistened with water or oil beforehand—or a carborundum can be used. Hollow chisels are more difficult to sharpen, and specially shaped stones which correspond to the shape of the blades are available for this purpose. It is best to resort to the advice of a professional carpenter or wood-carver in all questions of sharpening. When carving the block it is advisable to hold it in position with a clamp screw (before fixing it you should protect the block with two pieces of wood), or to knock two strong nails halfway into an old table against which the block is placed, thus preventing it from sliding during the cutting process.

Paper

Almost all types of paper can be used for machine printing so long as they have not been too heavily sized. It is, however, advisable to choose as smooth a paper surface as possible. For hand printing only highly absorbent and almost unsized paper is suitable, but this must at the same time be strong enough for rub-printing. If the paper is very glossy, the printing ink cannot penetrate it sufficiently and will remain on the surface, resulting in blurred contours or, in the case of gloss inks, in yellowish oil marks around the edges. Glossy paper also tends to slip off the block. Japanese or hand-made papers are most suitable. Some types of tissue paper can also be used, providing they possess the necessary strength, since they absorb ink very well. Japanese papers, which are tough and certainly extremely suitable for the purpose, are made from plant fibres and can be bought in art shops in different weights; they are soft and pliable, almost like fabric. If oil inks are employed, thin paper should be used so that during rub-printing you can check on the back of the paper where the ink has penetrated the paper and can adjust the amount accordingly. If you want to create definite black and white effects, thick, heavily sized paper is best. The choice of colour is a matter of personal taste, but in general white or slightly yellow paper is used for printing. Very strongly coloured paper can in certain cases be quite effective—even gold and silver paper. The Japanese also print on papers with faint colour irregularities—they are experts in improvising and exploiting chance effects. Various materials can also be used for printing with wood-blocks, for example linen, cotton, raw Indian silk, leather, parchment, cardboard, man-made fibres, rubber, etc.

Printing materials

Substitutes for watercolour printing inks as well as ordinary printing inks (varnish based) have already been discussed in the chapter on linocuts. It is even possible to print with ordinary watercolour slightly thinned with water. If it is too runny, powdered gum arabic which has been dissolved to a thick paste in hot water and then allowed to cool can be added. A small amount of glycerine prevents too rapid drying out and a few drops of carbolic acid increases the durability of the printing ink, so that it can be kept in an open bowl for a limited time. Instead of the roller recommended for inking-up lino blocks, a swab or dabber of the type usually employed in intaglio printing can also be used. You can make a dabber yourself by covering a small piece of rounded wood about 8 cm (3 in) in diameter with a wad of wool tied into a piece of leather. For larger surfaces the rubbing method with a spoon, the back of a comb or a paper folder would be too tedious, because although the paper is pressed hard against the block, it can only be done in strips. Should no press be available, I would recommend the so-called Japanese rubber, which one can also easily make oneself. From a board approximately 1 cm ($^3/_8$ in) thick a disc about 8 cm (3 in) in diameter is sawn out and notches cut all round it. A piece of corrugated paper is attached at the bottom and covered with greaseproof paper fixed tightly to one of the notches. A handle of some kind will make it easier to operate. Copying presses and copperplate presses (see the chapter on etching) produce a number of consistent prints, but limit individual variations.

Single and multicoloured prints

An impression of a lightly-inked block which has been planed but not carved will show up the structure of the wood. But even a carved block will, when printed, reveal the nature of the wood in its cut lines more or less strongly, depending on whether the carving is done with or against the grain. A number of illustrations show these rather special expressive qualities inherent in wood. In order to express a particular mood, a different background can sometimes be very effective; a lightly-inked, uncut block, for example, can provide a grey background for a second block. This is quite similar to the way in which multicoloured woodcuts and multicoloured linocuts are produced, i.e. in some cases a combination of the two. For preliminary practice the following two methods are recommended:

1. A black and white block with a number of uncut white sections is printed and then painted in watercolours so as to create a second shade. It is best to make more than one print of the key-block and to try out various colour distributions (i.e. overlapping edges, etc.) before deciding on a final version. Once you have made up your mind as to which composition you like best, make a second woodcut or linocut for the additional colour block. This can then be used for overprinting. Try not to be too fastidious or tentative when colouring in the print. Intriguing colour effects can be made by stressing or underplaying certain pictorial elements, or by contrasting the form and shapes of the black and white cut and the colour block.

2. When developing a colour scheme with two (or more) poster paints in your sketches, always bear in mind the effect on the end product, i.e. the colour block. The painted sketches can be corrected with white casein emulsion colour, which can then be overpainted. Additional blocks can also be made of linoleum, or stencils made from strong paper or cardboard can be used (see the section on stencil prints). In order to achieve exact registration of the various colour blocks, the needle point technique can be used. Dots and crosses are made in unobtrusive places on one of the blocks in positions which are roughly diagonally opposite each other, and these act as registration marks. The impression is punched by needles each time in these places first from front

German landscape Hap Grieshaber. Colour woodcut.

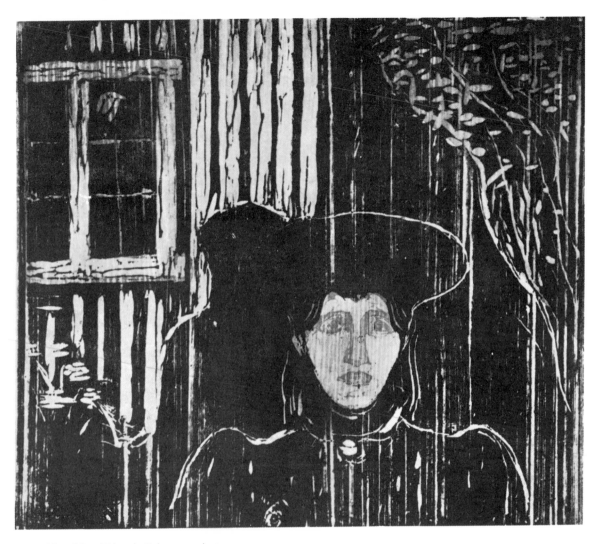

Moonshine Edvard Munch. Colour woodcut.

84

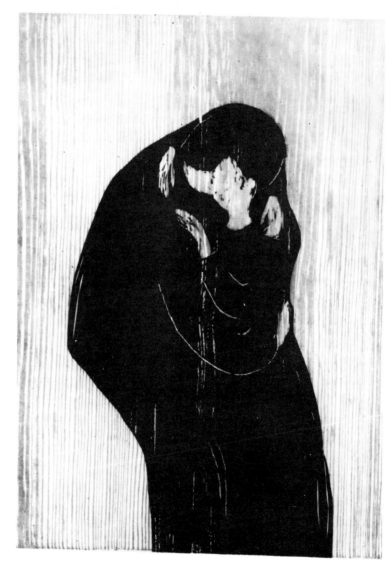

The Kiss Edvard Munch.

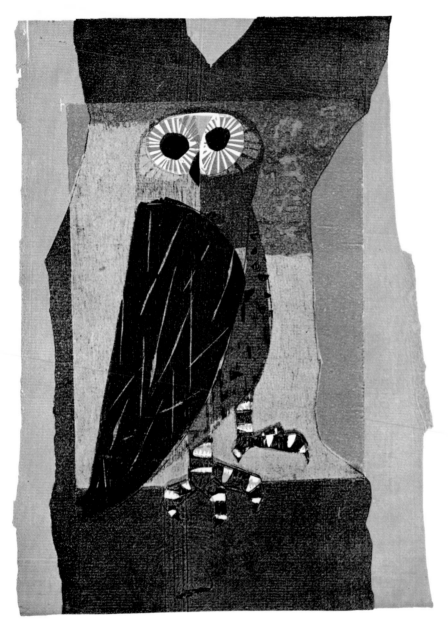

Owl in a tree Paul Wunderlich.
Colour woodcut.

to back and then transferred from back to front on to the next plate with the printing surface facing the block. During the printing process you will soon come to realize the importance of the order in which the colour blocks are printed and how any change of order will create completely different results. As a rule the key-block, which is usually printed black and carries the linear structure, is printed last. Modern graphic art, however, occasionally employs colour ranges which were developed by overprinting dark surfaces with very bright colours (containing a lot of white or opaque white). They have a strangely repressed quality, and sometimes look rather soapy.

The technical details for Paul Wunderlich's colour woodcut *Owl in a tree*, reproduced opposite, were as follows:

1. Material: maple and plywood blocks.
2. Inks: apart from black, all the inks were mixed with white (only job-printing inks were employed).
3. Printing: the brightest colour was printed first. All the blocks were printed straight after each other—i.e. wet on wet.

Printing order of colour blocks:

1. Brown
2. Green
3. Brownish black
4. Bluish black

In this way the surface texture was achieved. The drying process took a little longer than usual, due to the rather thick layers of ink. Non-absorbent paper was used for this relatively straightforward printing procedure.

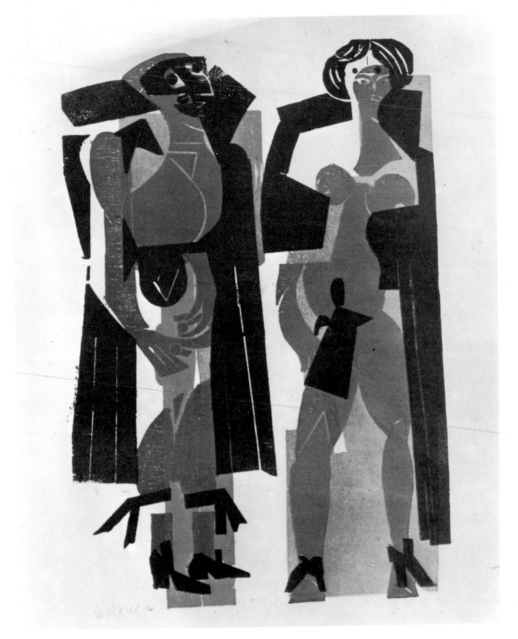

Woodcut. Hap Grieshaber.
Three-colour print.

Hap Grieshaber.
Colour woodcut.

Boy in foliage Otto Müller. Woodcut.

Chinese and Japanese printing techniques

Reference must be made to the fact that Chinese and Japanese woodcut printers used a much more complicated printing method. On the whole the ink was not applied with rollers, but painted on to the block with a brush in either thick or thin layers according to the painted sketch. Subtly flowing tones were obtained by blotting out or diluting the water-soluble printing ink with water. The most delicate tonal qualities and nuances were reproduced by moistening the paper during the printing process, by printing it dry, or by pressing it without any printing ink at all, in which case the paper is passed through the press and printed blind. Yet despite their great sensitivity, Chinese printers were even less concerned about uniform print editions than their Japanese colleagues. Nevertheless, only on closer inspection is it possible to detect minute differences within a single edition. But on further printings they show up more, as the first edition is generally printed according to the original, whereas the second

Girls at their toilet Hokusai.

1. Bamboo in snow from the *Mustard seed garden*.
2. Pomegranate fruit from the *Hall of the Ten Bamboos*.
3, 4. Utamaro: long pictures with two figures.

edition is made from an example of the first, the third according to a print of the second, etc. In view of the growing inconsistencies in later prints, one could almost class them as monoprints.

Metal engravings

In a discussion of woodcuts mention must be made of the so-called white-line engraving, which was developed along with the first linear woodcuts in the 15th century. Impressions were made for soft metal plates, instead of wood-blocks, and printed in the relief manner. Instruments similar to the burin were used. Parts to show up white in the design were engraved into the plate in the form of dots, lines, hatchings and decorative forms. The stippled background was made with punches similar to those used by goldsmiths for their decorative work. This is one reason why metal engravings sometimes have a somewhat fixed and impersonal appearance.

The use of identical decorative forms is also found in the intaglio printing method of stipple engravings, in which punches and special hammers are employed. The technique of white-line engraving is no longer used. The conscious exploitation of absolutely identical decorative forms of an almost mechanical appearance has occasionally been used by some modern artists (Braque, Picasso, Juan Gris and others).

An old metal engraving.

Parisian festival Hand-printed pictorial wallpaper.

Hand-printed wallpaper

Wallpaper used to be printed by hand, and the German Tapestry Museum in Kassel contains interesting examples of artistry and craftsmanship from all countries and periods. In ancient times designs were either embroidered or weaved into fabrics, garments and wall coverings, but the use of printed patterns made from wood-blocks or wax designs was also known. The chapter entitled 'A look at history' supplements the information given here, outlining the development of printed wallpapers, which were known early in China but were only discovered in Europe more than 200 years after the introduction of paper from the Far East. Reveillon was probably the first manufacturer to produce multicoloured wallpaper. The printers usually had the paper (which was hand-made) delivered from the paper mills in sheets of about 50 cm × 55 cm (20 in × 22 in)—today's standard width of wallpaper dates back to that practice—and they then glued together 16 sheets roughly 8 metres (26 ft) long and 50 cm (20 in) wide. The wallpaper was first of all sized with a hand brush, and then a pattern was printed on it with wood-blocks, each width of paper being placed on a printing table. An apprentice coloured the blocks at an inking-table, the printer positioned them, using registration marks for greater accuracy, and finally the ink was transferred to the paper by means of a lever-operated press. The paper was then moved on and printed again. A separate block was required for each colour, and this would mean that for one particular French specimen to be seen in the Museum, which is 100 cm × 50 cm (40 in × 20 in) and has 54 colours, 108 blocks had to be cut, and for really large pictorial papers up to 4000 blocks were needed. Velour papers are among the few papers left today which are still printed almost entirely by hand. A forerunner of this type of paper was one which consisted of sized sheets of linen coloured with oil paint and bronze powder, and printed with wood-blocks coated in glue. It was then placed in a long wooden box and covered with dyed, pulverized wool fibre (flock). The pattern was formed by the flock which had stuck to the glue. Flock papers have been made since 1560 and were particularly popular in the 17th and 18th centuries.

Lino cut. Karl Rössing.

Wood engraving. Rolf Hartung.

Wood engraving

Technical details

Wood engraving was developed from the woodcut and metal engraving. The tool used is a pointed graving tool not a blade, and the block consists of hard wood (usually box or pear wood). This is more suitable than softer wood for delicate lines, dots and hatchings, as was pointed out in the section on the scraperboard technique. The tool used for wood engraving is called a graver or burin, and is available in various forms. The French burin—as opposed to its German counterpart—has a short, curved handle which rests in the palm of the hand. It is pressed down with the hand and digs into the wood with its sharp point, ploughing fine furrows and leaving behind slivers of wood as it is pushed along. Plasticity can be achieved by decreasing or increasing the width of the lines. The handle should only be raised a little and drawn along as level as possible, so that the point can really bite into the wood. Quite a lot of physical strength is needed for working hard wood. It is best to experiment first with offcuts, trying out various techniques such as boring, gouging or engraving the wood, as well as studying the effect of dots, lines, patterns and diagonal and curved hatchings in relation to the tonal qualities of the design. In this way one is able to develop a closer understanding of the particular formal language of this medium, as opposed to the purely technical process of engraving which can be learnt in the relatively mechanical transfer from a drawing to a wood engraving. This method is also suitable for creating small book illustrations, decorative vignettes, illustrations and type—all finely detailed and capable of reproduction. Relatively hard timber cut *across* the grain allows a much larger number of impressions than blocks of timber cut *with* the grain.

Artistic considerations

From the technical point of view the difference between woodcut and wood engraving has always been greatly stressed. If, however, we examine the artistic quality of the two methods, there is only one important question to be taken into consideration: are these works of art an independent creation by an artist, are they originals, or are they facsimile woodcuts or engravings by a professional wood engraver? From the 15th

Delicate wood engraving structures. Hedwig Bauer.

century onwards, painters left this work to experienced craftsmen. If this had not been the case, Dürer, for example, would scarcely have been in a position to create such an enormous number of large and small woodcuts, so many hundreds of copper engravings, drawings, watercolours, paintings, documents and technical designs. It was often considered to be a sign of decadence—and in the last century with some justification—if wood-blocks were cut by an engraver following an artist's design. But it would be wrong to uphold this opinion without question, as the quality achieved must always be the prime consideration. Contemporary artists have rediscovered wood engraving as a technique which often suits their subject matter.

Impression of a slate cut, created by a child.

Cutting and engraving in other media

Rubber, lead, plaster, slate and brick cuts

There are many other materials suitable for making cuts and engravings which can then be printed in the relief manner. Similar rules are always applicable, modified only by the particular nature of the material used. Hard and soft rubber react differently to cuts or pressure. From hard rubber (such as certain types of floor covering), more precise cuts can be achieved than from linoleum or long-grain timber. Soft rubber is suitable for impression prints. Lead hardened with zinc or antimony can be used for detailed work and large editions. Cutting coarse-grained brick or slate plates calls for a simpler approach and requires less effort. The printed impression will reveal the individual nature of the material. Plaster blocks moulded in glass can also be carved and rub-printed. The range of materials which can be used depends on sheer inventiveness; the possibilities are endless.

Montage prints

Intriguing relief blocks can be made from flat, relief-like metal combinations mounted on hardboard. Centuries ago blocks were used for blue and white printed calico. Metal rods, tin strips and pieces of wire were inserted vertically into the wood so that they protruded about 5 mm (¼ in). These were used to transfer glue to the linen, which would in turn be dyed blue. More recently Rolf Nesch produced prints by relief printing from wood and metal plates which he mounted by riveting and soldering wires, pieces of tin punched, stamped or drilled with a patterned wire gauze, metal strips and other materials. Effects such as those described in the chapter on material

Bridge Rolf Nesch. Material print.

In the circus Pablo Picasso. Etching.

prints (page 62) could be developed even further by the use of colour and embossed print. The blocks could have been made in a tinsmith's workshop; a robust press and strong, hard-wearing paper are required for printing.

Embossed print and blind blocking occur as secondary results, and the artist can consciously exploit these.

Montage prints have much in common with material prints, which have already been discussed in the chapter on the introductory graphic techniques. Material prints, however, are built up by a number of printing stages and therefore always vary, like monoprints, whereas the montage relief block falls into the category of the real print-making methods, in which a high degree of regularity can be achieved and reproduction is always possible. Nevertheless, the technique of material prints serves as an excellent introduction to montage prints.

II. Intaglio printing

In the intaglio printing process the lines, dots and tonal areas depressed below the surface of the printing plate pick up the ink and print an impression of the design after the plate has been dabbed all over with printing ink and the parts in relief have been wiped clear again.

Copper engraving and dry-point

These two methods can be classed as the most direct manual intaglio printing techniques. Common to both is the process of pushing a pointed tool into the polished and shiny surface of a metal plate, thereby creating incised lines through the force of the engraver's hand. They differ in the type of tool used and its manipulation.

Copper engraving techniques and tools

The most frequently employed tool for copper engravings is the graver or burin, which has already been mentioned in the section on wood engraving. It is used for cutting or engraving the drawing into the copper plate. The burin is made of steel,

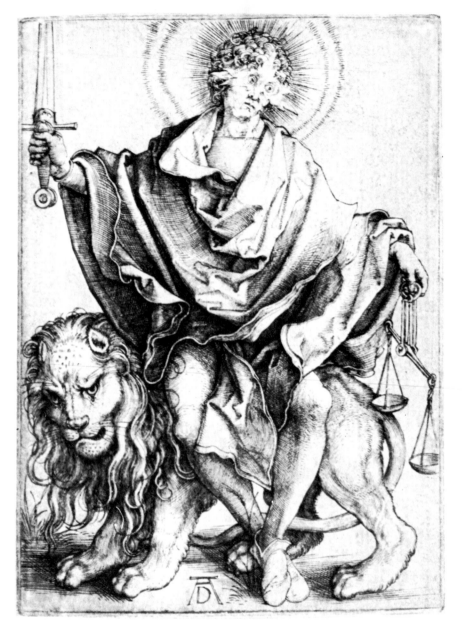

Justice Albrecht Dürer.
Copper engraving.

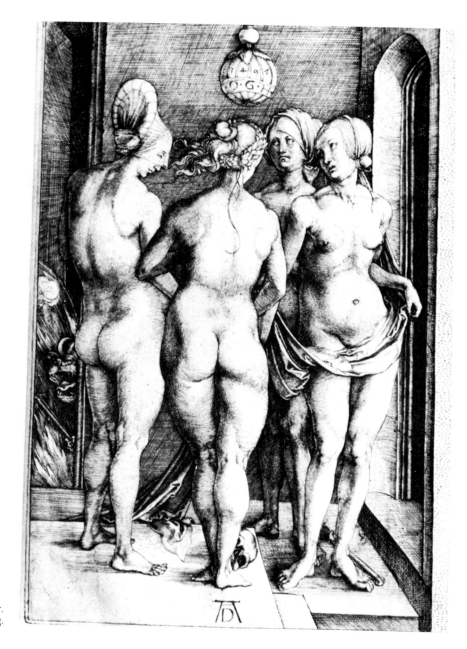

Four nude women Albrecht Dürer.
Copper engraving.

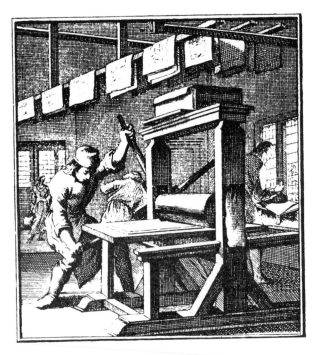

is about 12 cm (4¾ in) long, and has a square section and a lozenge-shaped point. Its wooden handle is ball-shaped, but flattened underneath so as to fit comfortably into the graver's hand. As in the case of wood engraving, a shaving of material thrown up by the passage of the burin is turned up at the side of the furrow. This is known as the burr and is generally removed with a scraper (a three-edged, pointed iron with a handle). Solid and fluted scrapers are available. It is pushed carefully across the plate, parallel to the lines, thus removing the burr left on the surface. Some practice is needed in order to be able to do this successfully, as one could easily damage the area around the lines with the scraper, which would result in an unwanted grey tone in the printed impression. This can, however, be corrected by polishing these parts with a lightly oiled burnisher until the damaged surface is smooth again and will remain white when printed. A copper engraving in Bosse's *The Art of Etching* shows an engraver resting his plate on a pad and, holding the burin perched over it, moving the plate in the required direction; in this way he managed to achieve perfect parallel lines which started as points and, after slowly thickening up, tapered to a point again.

Apart from burins, scrapers and burnishers there are many other copper engraving tools. An engraving bench will often be equipped with over sixty burins—square and lozenge burins, stipple and double burins—as well as engraving and other cutting needles, punches and roulettes. Copper engravings always look somewhat rigid and regular, and they have a linear quality which can be seen particularly well in the square hatching typical of this type of work. To the modern eye this rather rigid regularity might seem a little dull, but it should be remembered that engravers did not always create only original engravings designed and executed by themselves, but were usually conscientious craftsmen whose profession it was to translate any work of art into a reproductive medium. They were, therefore, not only expected to reproduce sketches specially designed for copper engraving by an artist, but also to transform masterpieces of drawing and painting into an engraved form, with the tones of the original accurately matched and avoiding any trace of their own individual style in the final print. This process demanded great skill on the part of the craftsmen. There were and are machines, however (for instance in process engraving establishments), with the help of which the straight, curved and crooked lines of drawings could be matched exactly. At this point copper engraving moves somewhat beyond the realms of the manual printmaking processes. Moreover, its specific importance is chiefly historical.

The tools and technique of dry-point

Contemporary artists have rediscovered an interest in engraving techniques, and the one most closely related to copper engraving is dry-point. Instead of a burin, a steel needle—also called a dry-point—is used. The process is so-called in contrast to the 'wet' process of etching which uses acid. The needle is generally a thin, four-edged or round steel 'pencil', sharpened to a point at one end and fixed into a wooden holder at the other. Engraving needles with three-edged, four-edged, round or oval cross-sections can also be used. Screw-in handles designed to fit detachable needles of different sizes and shapes are very practical.

The needle, in contrast to the burin, is held at an angle almost vertical to the surface, and care must be taken not to scratch unwanted marks into the metal plate. Individual lines can be drawn much more freely than in the case of a copperplate engraving. The artist can risk experimenting with lively irregularities. As dry-point produces finer

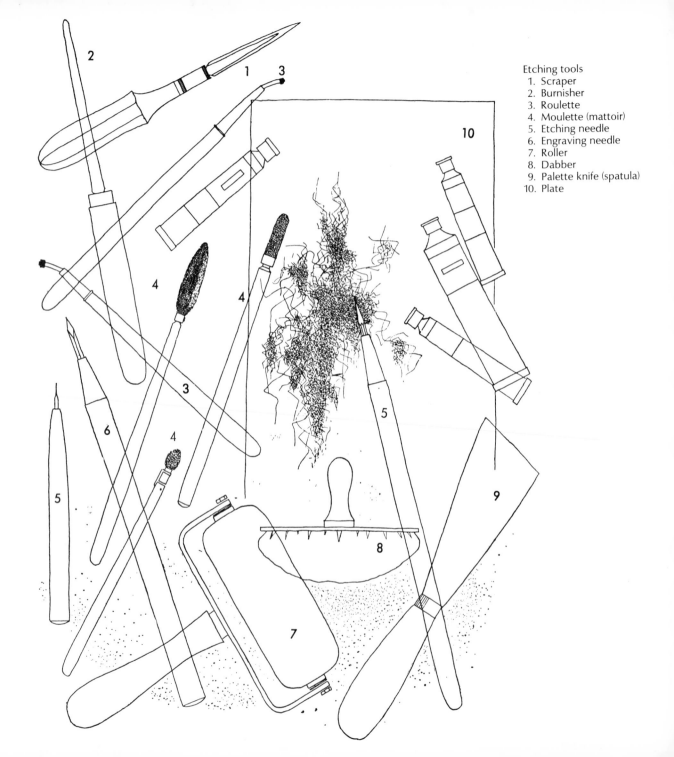

Etching tools
1. Scraper
2. Burnisher
3. Roulette
4. Moulette (mattoir)
5. Etching needle
6. Engraving needle
7. Roller
8. Dabber
9. Palette knife (spatula)
10. Plate

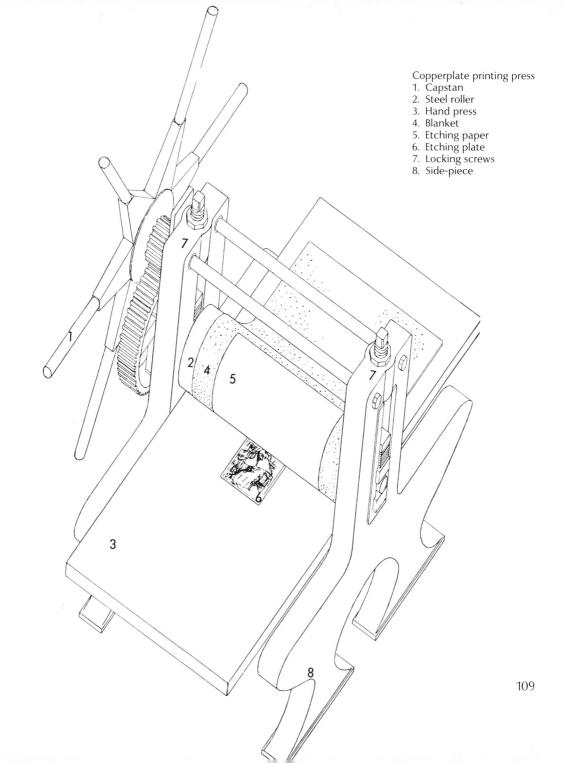

Copperplate printing press
1. Capstan
2. Steel roller
3. Hand press
4. Blanket
5. Etching paper
6. Etching plate
7. Locking screws
8. Side-piece

lines, subtle transitions and delicate nuances of tone, and allows great freedom of operation, painters have exploited its possibilities, and Corinth gave ample proof of the expressive and individual qualities of dry-point in his work.

Unlike line engraving, the burr which occurs at the side of the furrow is left in dry-point. Depending on the hardness of the metal and the pressure of printing, between six and thirty impressions can be taken without damaging the burr. As the relatively soft copper wears out fairly quickly, steel-facing the plate permits larger editions to be made. When it is dabbed on and rubbed off again, the ink not only collects in the main furrow of the depressed line, but also is caught by the burr on either side, and soft outlines accompanied by delicate double lines therefore develop on the plate paper. This is one of the characteristics of dry-point work when only a limited number of impressions have been printed. When a number of prints have been made, the burr is crushed and the accompanying double lines disappear.

Depending on the pressure exerted on the needle, the lines gouged into the plate will either be thick or thin; occasionally a thicker needle is exchanged for a finer one. The shape of the point (whether square, round or oval) is of little importance. Even broken sewing needles can be used in the screw-in type of needle holder; they can be stuck into an old paint brush handle and then fitted into the holder. Diamond styli are also popular. Scrapers, needles and burins should be sharpened from time to time on an oilstone or a carborundum with a little oil; it is best to fix the stone into a wooden block. There are no hard and fast rules for engraving the drawing. It is important to remember, however, that the needle should be held at an angle, almost vertical to the plate. The lines should not be too narrow in darker sections. Square hatching should be used with great care, since it tends to give a solid and rather dull impression, reminiscent of copper engraving. To begin with it is advisable to experiment with linear effects. Should a simple line look too thin—especially if the plate is quite large—fascicular lines, which have a very softening effect, can be drawn.

If you do not want to limit yourself to pure line drawing, grainy effects of a chalk-like quality and tonal surfaces can be achieved with a special tool and printed in the dry-point manner without retroussage. This tool, called a matting head, has a grained surface and a point. By using it large surfaces can be prepared which will print grey. Much the same effect can be achieved if a selected area of the polished plate is covered with a piece of glasspaper and pulled through the rollers of a press. Wire brushes which can be used for scratching the whole plate are also available. These grainy areas, which will print as tonal surfaces, can of course be polished away if not required.

Incisions with a slate pen result in light grey lines and surfaces. Special effects can be produced by the roulette and the moulette (see the illustration on page 116). The roulette consists of a small spur-like wheel fixed to a wooden or iron handle which stipples dots over the plate; these appear as tonal areas with soft edges or as wide, gently flowing lines. Related to the roulette is the moulette, which has a barrel-shaped head equipped with teeth; these also produce evenly grained surfaces, but they are coarser and less regular in quality.

It is possible to scratch the drawing immediately on to the plate with the needle, but people sometimes prefer to work from a sketch.

Greek and Turkish Forms Ben Nicholson.
Etching. Courtesy Marlborough Fine Art (London)
Ltd.

The Plain at Belaye Anthony Gross. Etching.
Courtesy Maltzahn Gallery, London.

Self Portrait David Hockney.
Etching. Courtesy of the
Kasmin Gallery, London.

The sick girl Edvard Munch. Dry-point.

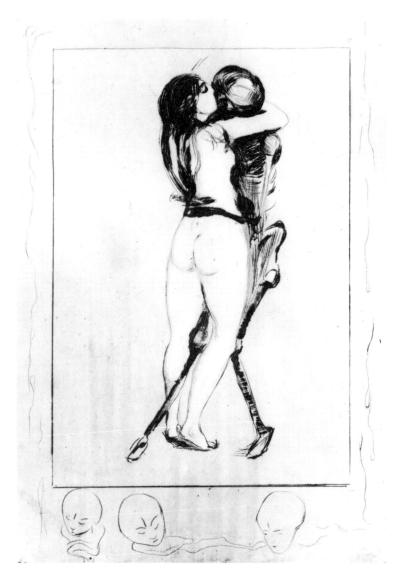

The girl and death Edvard Munch. Dry-point.

Sand-paper traces.
above: pressed on.
below: wiped.

Various roulette and moulette lines.

Dry-point effects

Experimenting with various tools and etching
techniques.

Zinc plate, original size.

The plates

Dry-point usually employs metal plates—copper, brass, zinc or light metal. It is possible, however, to make do with plexiglass, strong cellophane or pressboard (a highly glazed board, resembling vulcanized fibre). Copper is undoubtedly the best but also the most expensive material for etching plates, followed by brass. Both these metals are available in various grades of hardness. Softer material is, of course, easier to work, but will only yield a limited number of good impressions. For larger editions the plate

...sist method.
...ching 5 minutes.
...quatint etching 2 ½ minutes.

Line etching.
Etching time
(from top to bottom)
7 ½, 5, 4, 3, 2 minutes.

Aquatint tonal surfaces; etching times:
10 secs 20 secs 30 secs 40 secs 60 secs.

should be steel-faced, as is done with copper engravings. For your first attempts, it is a good idea to use any odd pieces of zinc or light metal which you may be able to get hold of. The plates can vary in thickness from 1 to 3 mm ($\frac{1}{25}$ to $\frac{1}{8}$ in). They should be cut in the shape of rectangles and the edges bevelled with a file and a pumice stone to produce a flange. This will prevent the paper from being cut by the edges of the plate. If you want a shiny etching surface, the plate should be well polished. All traces of dirt, especially smears of grease, must be carefully removed. In order to achieve this, the plate is first sprayed with turpentine, and then wiped thoroughly with a clean, soft pad, after which it is rubbed down with whitening and spirit. If there

are rather a lot of dirt marks on the plate (oxide spots, for example), it can be polished with a very weak alkali solution; a cork can be used for wiping clean. One can then draw directly on to the plate. Since the incised lines are not always easy to see, it is a good idea to fix a large sloping screen covered with transparent paper to the window to diffuse the light. If you then place your workbench beneath the window, you will be able to distinguish the lines more easily.

The printing process

In relief printing the block is rolled up and the parts in relief receive the printing ink; in intaglio work the ink is rubbed into the surface of the plate with a pad and a dabber (see page 108). It is best to mix the fairly thick copperplate printing ink with a spatula on an old litho stone and then apply it with circular rubbing movements on to the warmed metal plate, so that all the incisions receive and retain the ink. By warming the plate the ink is kept pliant and runny. The plate is then wiped with a pad of fine canvas, care being taken not to remove the ink from the incised lines; for this reason it is best not to rub in the same direction as the incisions. The brighter parts of the plate surface can also be given a further wiping with the palm of the hand if necessary. It is then placed on the base of the hand press or on the steel bed of the copperplate press and carefully covered with plate paper or board, the latter having been moistened the day before. Finally the paper is covered with the blanket, part of which remains under the steel roller (see the isometric drawing illustrated on page 109), and the whole is moved through the rotating steel rollers of the press, which must be correctly adjusted. After the first impressions have been made, it may be necessary to make a few alterations to the incised drawing; certain parts can be made to stand out more strongly by additional incisions, by deepening already existing lines or by burnishing lines out or scraping them off. After this first proof, or so-called 'state', prints are made from the second state, but sometimes there are even further corrections to be made, each resulting in a new state before the final proof is pulled. Each stage in the development of an engraving or etching thus constitutes a state. The last state is not always the best and the first etched or engraved states by famous artists, which naturally consist of a very small number of printed copies and often show the artist's original idea and inspiration best, are in great demand among collectors.

After some twenty or thirty impressions (depending on the hardness of the metal), the plate wears out to some extent, and the delicate lines and particularly the burr

tends to get lost. For this reason valuable plates are often steel-faced, which is achieved by electrolysis depositing a microscopic film of steel on the surface which hardens it sufficiently to allow the printing of several thousand identical impressions. The term 'retroussage' is used to describe the action of passing a ball of muslin over an inked plate, with the intention of dragging some of the ink out of the incisions and smearing it across the plate. This tone process can be very effective, but should only be used occasionally and with great care. The pictorial means of dry-point are dot, line and hatching, and tonal effects can be achieved by a combination of these elements

Tree Etching.

Wiped clear.

Hand tone.

Tree Etching
with retroussage.

without the help of retroussage, which could be considered cheating. If special tonal effects are required, it would be more advisable to choose either the aquatint or the mezzotint technique.

Improvised printing methods

It is often difficult to gain access to a copperplate printing press, and I would therefore like to outline a few other methods by which prints can be obtained. A dry-point can be reproduced by 'rub-printing' with a spoon or paper folder in the same way as cuts and monoprints. However, even greater care is needed if this method is to be employed successfully. It is a good idea to cover the moistened plate paper with a dry, smooth sheet of strong paper, which will then protect the soft plate paper when the impression is rubbed on to it (a little bit of soap will make the spoon slide more easily). Dry-point impressions can be taken successfully from linoleum, plexiglass, Cellophane, pressboard, gutta percha and even wax, as well as from metal plates. All these materials can be incised with the steel needle, but will only print a small number of impressions. With some materials, pressboard for example, it is advisable to use a specially designed knife to achieve the typical dry-point effect, as the sharp, pointed steel needle would tear the paper fibres and give rise to smudged, irregular lines and messy prints. Some firms produce plates suitable for dry-point which look very much like plexiglass, and they provide special tools to go with them. These are excellent for school use. But graphic artists have not yet dispensed with metal plates, as they still yield the best results. Apart from the plate paper already mentioned, white or slightly yellow unsized, hand-made paper is most suitable.

Steel and zinc engraving

Both these techniques are closely related to copper engraving. Steel engraving was invented in 1820 by the Englishman C. Heath and has been used for illustrations, banknotes, letter-heads and visiting cards; the lettering employed often consisted of finely drawn, decorative lines. The image is transferred to the steel plate in the same way as with copper engraving.

Zinc engraving was developed to overcome the difficulties of engraving in heavy, unmanageable stone and to take advantage of the special qualities of zinc, which is

softer and cheaper than copper. Senefelder used zinc to engrave the plans of Reichen-hall. Jules Gailhabaud's *Monuments of Architecture* contains masterly zinc engravings.

Etching

The depth and width of the incised line in dry-point and copper engraving is deter-mined by the pressure of the hand as well as by the tools and materials themselves. This is not the case with the etched line. Here the metal plate is first of all covered with a specially prepared ground (consisting mainly of asphalt tar and wax) which can be rolled on, or the plate can be coated with a commercially produced etching-ground. This thin coating is engraved by the etching needle when this is moved lightly across it. The back of the plate is protected with an asphalt-based varnish, which is an acid-resistant, before it is immersed in an acid bath (iron chloride, nitric acid or hydrochloric acid). The acid bites into the metal where the etching ground has been pierced by the needle. The depth and breadth of the 'bitten' lines depend on the length of time the plate is left in the acid bath. Variations in the depth of the lines is achieved by taking the plate out of the acid at various stages and by stopping-out the intended faint lines with varnish. Those parts which are etched for the greatest length of time will appear strongest in the printed impression, while those stopped-out after the first etching stage will appear as the most delicate lines in the print.

During the etching, the bubbles caused by the acid should be carefully removed from the lines with a feather. The chief difference between the etched line and the dry-point line is the absence of a burr, and its accompanying tonal effect at the side of the furrow. The etched line shows harder divisions, but thicker lines often have torn and brittle edges of relatively even strength. The overall effect is somewhat colder and more technical than dry-point. Picasso's line etching *Deucalion and Pyrrha* (see page 123) shows how expressive the pure line can be in the hands of a masterly artist, despite its rather cold uniformity. The etching *Dying leaves* (page 129) shows textures and tonal effects. The great advantage of the etched line is the ease with which it can be created on the etching ground, which means that continuous lines require far less effort and the possibility of the needle slipping becomes less likely. Apart from this, spoilt lines can be removed easily and quickly by painting them over with etching ground or asphalt. Occasionally artists of different epochs have combined etching and dry-point, and have achieved particular graphic effects which would have been difficult to create by any other method. The printing procedure for an etched plate is the same as for dry-point.

Deucalion and Pyrrha Pablo Picasso. Line etching.

Self-portrait with Saxkia Rembrandt.

The three cottages Rembrandt. Etching.

The Christchild surrounded by the scribes
Rembrandt. Etching.

Studies, etching. Rembrandt.

Christ teaching Rembrandt. Etching.

'Fashion copper engravings', 1823, 1820. Hand-coloured.

Dying leaves
Etched line; detail.

Que se la llevaron!

and they abducted her Goya.
Aquatint

Self-portrait Goya. Aquatint.

Birds of a feather flock together
Goya.

God forgive her: and she was her mother Goya.

Aquatint

You may want to enliven a line etching by adding tonal surfaces, or you may wish to create an etching based entirely on tone rather than line. This can be achieved by retroussage (as in the case of a monoprint), which results in prints with individual variations. The most appropriate technique for this is aquatint. The metal plate is covered with a porous ground, either by putting it into a box or by sprinkling it evenly with colophony (resin dust), which can be done by tapping a linen bag filled with colophony with a stick. The plate is warmed slightly over a candle or a hotplate, just enough for the particles of resin dust to melt without becoming too liquid. Pure whites— as well as the back of the plate—are stopped out with asphalt or etching ground. In the acid bath the plate is bitten between the particles, forming an even network of fine lines which will print as a grey tint. The etching ground and the resin particles must be removed with turpentine and spirit before pulls from the plate are made. If deeper tints are required, a new coat of resin dust can be melted on to the plate; parts to remain unaffected are stopped out with etching ground, and a further aquatint tone is etched. Obviously those surfaces which have been etched a number of times will appear darker when printed. As with mezzotint, dark tones can be lightened by careful use of the scraper and burnisher, and as with the etched line, a tonal range can be obtained by immersing the plate in the acid, removing it and stopping lines out before immersing it again. Great tonal subtlety can be achieved in this way. It can also be very effective if, instead of using plain black ink, dark brown or a mixture of black and green or black and blue ink is used for printing.

The aquatint process encourages technical variations. Some artists use a brush dipped in acid to paint on to a zinc plate coated with melted resin dust. The result resembles a brush drawing with varying tonal surfaces. Variations of texture can also be achieved by wiping or dusting the plate while the resin dust is melted on and by then applying a second sprinkling; this results in decorative surface effects. Lines drawn with litho chalk on the aquatint ground also produce striking contrasts when the plate is re-etched.

Soft-ground etching (Vernis mou)

Although dry-point and etched line are very different from each other, they have one thing in common: they can both print firm and sharp outlines giving an impression of relative hardness. Soft, wide and grainy lines can be achieved by using *vernis mou*—a soft, jelly-like etching ground through which one draws by a special tracing method.

The drawing is not made straight on to the plate coated with *vernis mou* or scratched out of it, but is made on a thin sheet of paper laid on top of it. The drawing is made by exerting pressure with a hard pencil. As a result of the pressure the soft etching ground sticks to the paper and can be lifted off with it. Depending on the structure of the paper, a number of traces will have remained on the plate, which is now put into an acid bath like an etching. The lines and surfaces created in this way vary according to the roughness of the paper and the softness of the pencil. Etchings printed from these plates have a peculiarly soft and grainy line, rather like pencil lines.

Although it can be bought ready-made, the following is a method of making your own *vernis mou* ground. Soft varnish is made by melting equal amounts of ordinary varnish and mutton tallow in a basin over a bowl of simmering water. When the mixture has cooled, shape it into balls or short rods. In warm weather one third of mutton tallow is sufficient for the mixture. The resultant *vernis mou* coating should be kept in a small glass tube. Apply it to a well-polished and slightly heated plate, which should have been previously painted with the thinnest possible coat of beef or mutton tallow (use a fine piece of muslin for this). Dab it on after you have heated the plate and distribute it evenly with a leather roller (priming roller), so that the plate is covered with a very thin layer. The plate can now be re-heated for a moment, and then re-cooled. After cooling, the drawing paper is put across the plate and attached at the back. When dealing with larger sizes, a composing stick can be used. It is a good idea to move the bowl containing the acid every now and then during the etching process in order to distribute the bubbles evenly; but you must not touch it with a pen at this point as this would damage the delicate, soft ground. Strong, thinly applied printing ink can also be used as a substitute for the *vernis mou* etching ground.

Stone engraving

This is an intaglio printing process like copper engraving, though the stone is usually treated according to the principles of surface printing. Senefelder invented it as one of his first graphic methods, cutting a plan of the area round Munich in stone. To achieve sharp and definite lines immaculate stones of a grey or blue colour are preferable. As the deep-lying parts are supposed to print, the capacity for absorption of paint or ink of the higher parts must be rendered ineffective before the engraving is made. One way of achieving this is by using oxalic acid (salt of sorrel mixed with gum arabic and water). Oxalic lime develops out of the calcium of the stone, and this covers the whole surface of the stone like solid varnish.

Joseph as a shepherd
Marc Chagall. Etching.

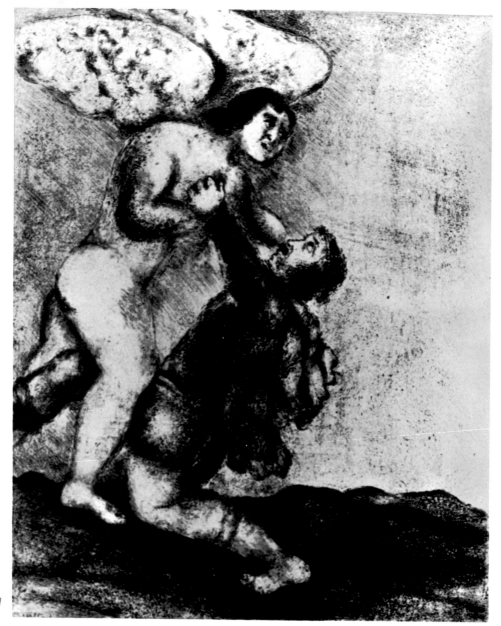

Jacob's struggle with the angel
Marc Chagall. Etching.

In the course of time copperplate engravings have become more popular than stone. Copper plates are more durable, present infinite possibilities of correction, can be easily transported and stored, and are more suitable for photo-mechanically produced reproductions.

Mezzotint

In order to give a complete picture mention should also be made of mezzotint or *manière noire*, which developed from line copper engraving and is related to the roulette and moulette technique of etching. It is hardly practised any more. Like line etching it has remained almost exclusively a reproduction technique, despite the fact that it was the first printing technique which could reproduce 'real' half-tones.

The plate is covered with a mesh of small burred dots, made by a toothed, chisel-like rocker or rocking tool. In this state the plate would print as a solid, rich black. Lights are obtained by scraping off the burr with a scraper—a knife-like instrument—and polishing the plate smooth again with a burnisher; in this way the contours of the drawing are created. As this technique makes it possible to produce particularly soft and interflowing tonal surfaces with soft contours, it was greatly used for the repro- duction of paintings. If the scraper or burnisher only is used, the drawing tends to look somewhat weak and undefined. Usually work was carried further, the plates being treated with burin and cutting needles; in this way they were made to render the tonal scales of the paintings.

Mezzotint was invented in 1609 by an amateur, the officer Ludwig von Siegen. It corresponded with the spirit of Dutch painting. Everything was developed from the principle of light and dark—the *clair obscur*. In English engraving mezzotint experienced its prime. For original manual engravings the interest was centred more on proper etchings, in particular dry-point, line etching and aquatint.

Material impression technique

This technique is linked with the technique of soft-ground etching. An impression of a piece of material (silk, canvas or gauze) is made on selected spots of a soft ground by rubbing the material down with a burnisher and thereby creating textural imprints.

Above: Detail from a brush-aquatint etching. Hermann Teuber.

Below: soft-ground etching.

139

The paper covers are essential. The resulting imprints are like those of the litho prints to be discussed later; they are technically quite outstanding and can be used as part of an artistic creation.

The plate is printed in the same way as with any other method. It is, of course, more sensitive than an etching engraved with a needle on an etching ground and etched in acid (line etching and aquatint), but not as sensitive as a dry-point etching or any work where only the roulette and moulette technique is applied.

It is a good idea to have sensitive plates, needing no more correction, steel-faced immediately after the first trial prints. Any amount of impressions can be made from steel-faced plates without decline in quality.

Resist printing techniques

In the chapter on introductory graphic techniques, negative techniques and the accompanying resist drawing were discussed at length. But even more interesting is the method of resist printing—also called resist—from which impressions can be taken and which, as a result, can be classed as a proper method of manual printing.

In the case of litho prints which are described later, this is done by making a sketch with gum arabic on stone; there are various methods which can be applied for etchings.

The paint to be used must be easily soluble in water once it has dried under the etching ground. The drawing is made on a well-polished but not too shiny plate, from which all grease has been removed with ordinary, freshly-mixed ink containing sugar or with a mixture of Krems white, gum arabic and a little sugar-candy (the mixture should look like permanent white), or with paint containing two parts of genuine cinnabar and one part of finely powdered and well-mixed pine soot. The powder should be treated with gum arabic which has been dissolved in water beforehand till it turns into a liquid suitable for writing and drawing.

The tools used for drawing on the plate are a steel pen, a reed pen, or a fine-hair or bristle brush. As soon as the paint has dried on the plate base, it is grounded with varnish, that is painted over, or warmed up and rollered like an ordinary etching. A second coat of soot is not necessary in this case. When the plate has cooled it is washed with water using a sponge or a bushy brush, or it is placed for an hour in cold

Detail of a robe. Lambert Krahe. Mezzotint
portrait enlarged four times.

water. The etching ground now detaches itself from the parts drawn on—it can be
removed easily by rubbing it with a finger or a soft flannel—sticking firmly to the
parts *not* drawn on. The plate is now put into an acid bath like an etching (see the
chapter on etchings). On the whole it is advisable to apply an aquatint ground especially
if the drawing was executed with wide strokes or areas, before etching it in the acid.
By this method lines similar to the strokes of the reed pen or the inking brush can
be achieved and reproduced. It is also suitable for decorative design. Resist printing
requires particular care, and it is therefore advisable first to experiment with all the
effects which can be created.

Stipple engraving

This method was used in conjunction with that of line engravings and is now only of historical interest. A punch was put on a copper plate and by applying hammer-blows to it, traces were created which could then be turned into patterns and mouldings. The punch is really a goldsmith's tool. In earlier centuries many copper engravings, those of Bartolozzi, for example, were produced in this rather mechanical and crafts-man-like way. Specially-made pointed hammers were often used instead of punches. Stipple engraving, classed as an intaglio printing process, could be regarded as the artistic counterpart of the mezzotint plates (a relief printing process). In both cases mechanical, ornamental shapes are created and repeated; rhythm is replaced by time and beat.

Crayon manner

The crayon manner, formerly practised in France, is a rather strange graphic process. The prints have an effect similar to chalk drawings. In this technique, which is entirely confined to the use of a roulette combined with the so-called mattoir, which has a club-shaped point, punches and strokes are created which are made up of closely-spaced dots of strong or weak quality. The impressions are reminiscent of chalk lithographs or silverpoint drawings, and were often executed in red ochre and sometimes in bistre (a brown pigment prepared from soot).

It is no coincidence that this stipple and crayon method was particularly popular in 18th-century France. It was the most suitable reproduction technique for the chalk drawings of Boucher and Huët, and in Louis Marin Bonnet they had found an ideal translator. Demarteau and Bonnet also used the crayon manner for colour prints.

Colour etchings

Those who are not familiar with the subject might be inclined to think that colour goes against the true nature of an etching. However, as many coloured copper engravings were made in the past, and as artists produce coloured etchings—especially in France—this subject ought to be discussed, though we are here only interested in the most common methods.

There are three ways of creating a colour etching. The first method prints from a single plate. The engraved and etched plate is like a coloured monoprint, rubbed, dabbed or carefully painted with oil paint or printer's ink, and then printed. Such prints often produce quite startling chance effects. Transparent and opaque colour, colour as the prime element and colour out of value can be applied with this technique; thickly applied paint, of course, works against the delicate quality of an etching.

Some artists prime the plate with a grey or brownish shade, as with an ordinary etching and then paint additional colours with a pointed inking brush in order to liven it up. It is, of course, impossible to print a number of identical impressions with this method.

The second method of creating coloured etchings is by shading the finished etching or by adding colourful effects, but this cannot strictly be classed as a printing technique.

Although surprising and instructive results can sometimes be achieved by using these two methods, one feels that the limits of genuine picture printing have been exceeded and that we have already crossed over into the field of painting. The third technique, on the other hand, has its own definite working style; this does not exclude chance effects, but keeps them within certain limits and does not flow excessively.

Flowing can be avoided by printing each individual colour from a separate plate for one picture. Certain inconsistencies are, however, unavoidable, as the dampened etching paper tends to stretch after frequently passing through the copperplate press. This technique requires a lot of patience and practice, and can really only be done by the artist himself.

Each colour plate is treated like a black-and-white plate. The appropriate colour is applied and the plate is then printed, the black plate being printed last. As aquatints can be etched in varying degrees of strength, a number of tone variations will result from a single colour plate. These are increased when the whole range from black to the original paper tone are added. Some graphic artists saw or drill small sections out of the etching plates. This results in untreated paper showing up on the print, and embossed printing makes them stand out even more, thus emphasizing the contrast. Light and dark colour variations can here be used to their extreme.

It is advisable to use only one plate for each colour. This will preserve clarity and help to avoid painting on the plate at the same time, so that a number of the same print can be produced.

Festive signs
Otto Eglau.

III. Surface printing

Here the directly drawn or painted, flat-lying parts of the block (stone or metal plate) take the printing ink from the roller and show up on the print, while the more or less equally high, unpainted parts of the block repel the ink.

Lithography

This is the best-known surface printing technique. Solnhofener slate is a limestone with the quality to take both water and grease. Its surface is polished when wet with granular quartz sand using grindstones of varying degrees of hardness. After it has been washed and dried it is drawn or painted with lithographic ink or chalk. Some artists prefer to draw on the stone with printer's ink instead of lithographic ink.

Polishing the stone

First of all something must be said about the polishing and graining of the stones. The stone to be grained is wetted thoroughly, sprinkled with sand and, if possible, pre-polished with a hand-grinder. Particular attention should be paid to guiding the grinder evenly across the stone in order to create a flat surface. After this, litho grinding stones are used, two or three different hardnesses being employed. Softer stones attack more strongly, but tend to make light scratches; as these can show up on the print, it is advisable to use a harder grinding stone for the final polish. One must remember to keep the stone wet all the time. When it has been ground smooth, the stone is washed and dried. It can now be used for black-and-white work.

Graining

Apart from this, there is the more convenient, but not entirely recommended method of machine graining. For electric machine graining, good tools which can be operated by one person alone are available. Interchangeable graining plates or stones rotate on the stone to be polished, which has previously been covered thoroughly with screened sand and water. The stone can be polished, and even grained, within a few minutes. It is preferable to do the final graining by hand. Screened glass sand, any silver sand, or ground flint are most suitable for graining. When the sand has been ground too finely it must be changed. The fineness of the grain of the stone depends on the amount of time working the stone and the coarseness of the sand. One can judge whether the correct level of graining has been achieved by holding the dry stone at an angle against the light. In general it is a good idea to choose a grain that is not too coarse.

Further working of the stone

If the grey tones of an ink or chalk drawing are to be reproduced, the stone has to be roughened. After the lithographic stone has been polished with litho grinding stones and then cleaned, it is dampened again and sprinkled with glass sand. It is best to use a fine hair-sieve to filter out impurities in the graining sand for this purpose. A small lithographic stone about 20 cm to 25 cm (8 in–10 in) long is wetted and placed with the dampened side on top of the stone to be grained. The top stone is then carefully moved to and fro in wavy lines. If a coarse grain is causing scratches, this can be both heard and felt. The stone is now moved evenly till it sticks. This will take some time and depends on the hardness of the stone. The hard quartz sand will then have been pulverized completely and will feel like fine flour. It must be pointed out that no water is added during the graining process. A coarser grain can be achieved by adding more graining sand and reducing the working time. As usual a certain amount of experience is needed. If one grains for too long, it is possible to grind the stone smooth again. As soon as it has been grained, the stone is washed and dried.

Machine graining

When a design has been drawn on the stone it is 'etched'; in other words, prepared for printing. The drawing is protected by dusting it with talcum powder. The stone is

Lithograph. Karl Hofer.

147

then painted evenly with gum arabic and nitric acid. Bubbles will form, due to the escape of carbon dioxide. The open pores of the stone close and will not absorb any more grease. The chalk gradually softens and turns into soap in the stone. In this way chalk and ink become water-insoluble. It is particularly important with chalk drawings that the etching solution is left to dry in its own time; if it is washed too soon, chalk parts which have not yet combined might dissolve and ruin the whole drawing. There is no set rule for the strength of the etching fluid. Type of work, hardness of stone and temperature play a part. It is better to etch too lightly than too strongly. A rough surface or, even worse, relief formations must not develop under any circumstances. When the etching solution is dry it is washed off with water. Great care should be paid to the edges, so that no sediment remains there, for this might at a later stage be wiped on to the stone. After this, turpentine is applied to the damp stone; the stone is then washed out. The drawing will disappear almost completely. A little bit of washable tincture, which can quickly and easily be distributed over the stone, will make the drawing reappear; the tincture supplies the drawing with grease.

First proof

A large, slightly rough leather roller covered with printing ink is now rolled a few times over the wetted stone. Gradually the drawing becomes stronger and more visible. It is clearly noticeable how the greasy drawing rejects the water, whilst it remains on the parts not drawn on and slowly evaporates. The roller leaves the equally greasy ink only on the dry parts. Should one of the blank parts of the stone be left dry by mistake, it will also turn black when the ink is rolled on. When enough ink has been rolled on, a sheet is put on the stone, on top of which goes the pressboard—an oily piece of cardboard which slides freely when tallow or grease has been rubbed into it. Now the stone is guided in the type-bed (see the drawing opposite) under the inked pad, a piece of hardwood shaped like a roof and covered with a strip of leather at the bottom. By means of a lever this inked pad is pressed on the oiled cardboard, the paper and the stone; the pressure of the lever then cranks them through on the type-bed. After the lever has been set upright and the type-bed drawn back again, a first proof can be withdrawn from beneath the pressboard. As a rule it will not show a strong impression, as the stone which has to be rolled with ink rather carefully will only take and reproduce it completely after a number of trial prints.

Whereas in the case of the copperplate press (see page 109), the steel rollers are put

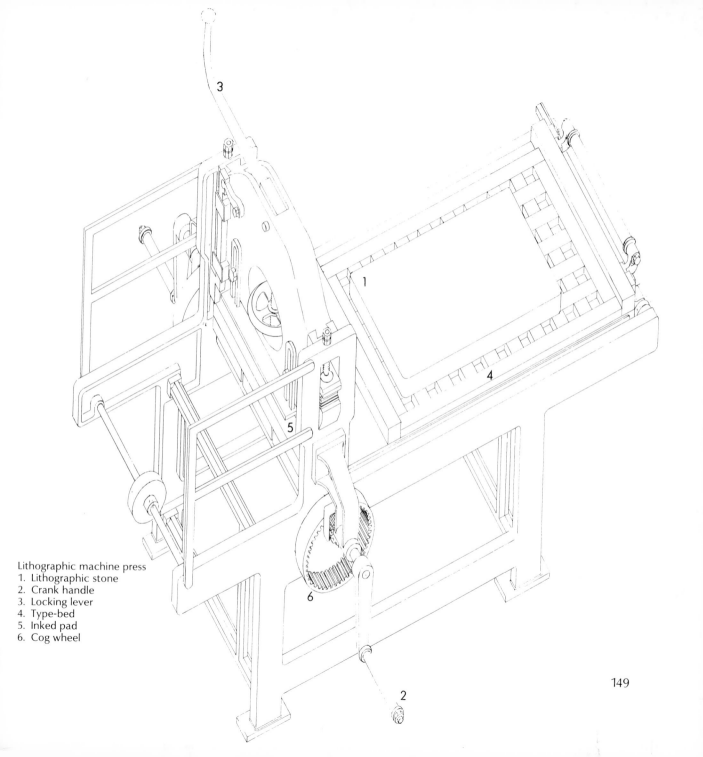

Lithographic machine press
1. Lithographic stone
2. Crank handle
3. Locking lever
4. Type-bed
5. Inked pad
6. Cog wheel

149

into motion by rotating the capstan, the lithographic machine press works by winding the crank, which will then move the mobile type-bed with the litho stone under the rubber (hardly visible in the drawing). The lever presses the rubber firmly against the stone sliding under it.

Corrections and additions

Should there be something unwanted on the proof, additional corrections on the stone are possible. Small parts can be ground or scraped off with pumice or correcting-stone dipped in water beforehand. Corrections can also be made by scraping out with pointed needles or knives. If necessary, the stone can be deoxidized. This is done by washing it with clear water and then applying wood vinegar or alum to the stone. Let it act on the stone for a while, and then wash and dry it off again; a wind-flag or a hot-air hair drier would speed up the drying process. The wind-flag is a piece of cardboard between 30 cm and 40 cm (12 in and 16 in) long, which rotates round a rod. As well as corrections, additions can also be made at this point. For the print, however, the stone must be prepared as usual: application of talcum powder, etching solution, etc.

One should also mention that after printing the stone must be painted with gum arabic. If this were not done, the drawing would soon be no longer impressible.

Drawing on the stone

The process of preparing the stone might seem difficult and mysterious to the layman, but the method of drawing on the stone might well strike him as easy. Instead of the usual drawing materials, lithographic ink and litho chalk of varying hardness are used. The ink can be applied with a drawing or writing pen, with a ruling-pen or a reed pen, with a hair or bristle brush, or with a wire sieve. One should avoid touching the stone with the hand, as it will react to even the slightest trace of grease. A composing stick placed across the stone (on which to rest your hand) is most helpful.

Unlike the strict rules concerning the choice of material which have to be kept in the case of a technically correct woodcut, everything from the purely mechanical side—in this case the drawing—is possible. Lithography allows great freedom in matters of technical and pictorial materials.

Woman in a flowered blouse Pablo Picasso.
Zincograph.

Studio picture Antoni Clavé. Colour lithograph.

Helios Georges Braque. Colour lithograph.

153

Jaqueline reading Pablo Picasso
Lithograph.

154

Marrakesh Oskar Kokoschka. Lithograph.
Courtesy Marlborough Fine Art (London) Ltd.

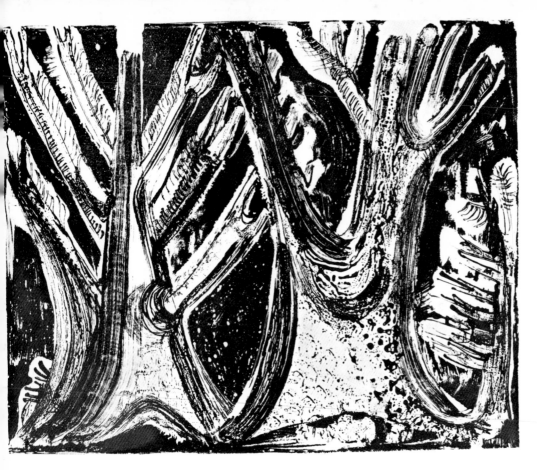

Use of gum arabic and petrol.

Gipsy children Renate Rhein-Rehmann. Positive and negative lithographs (left and right).

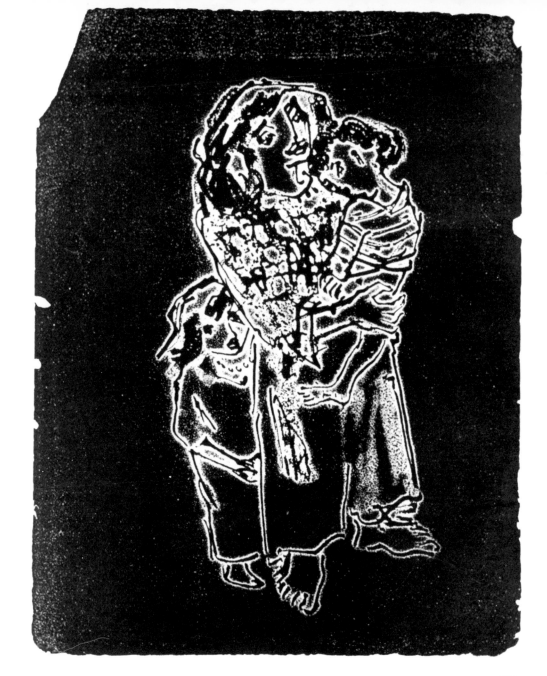

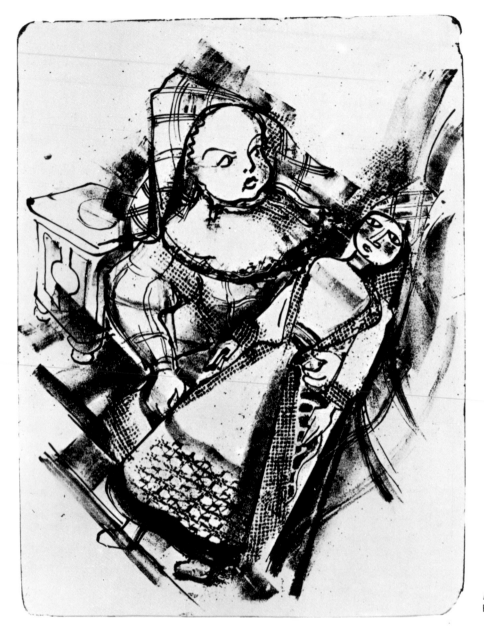

Dutch child with doll Erich Rhein.
Reed pen, chalk and texture.

158

...ansposition of the same lithograph
...to negative.

Pasing Alexander Kanold. Lithograph.

Olevano Alexander Kanold. Lithograph.

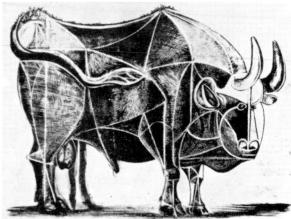
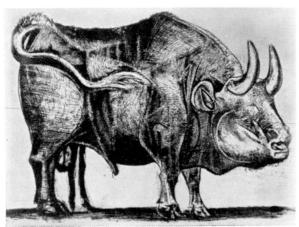
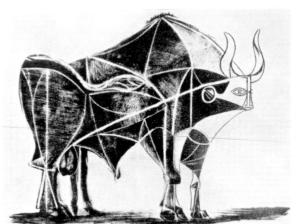

Le taureau Pablo Picasso. Lithographs. Sequence of eight prints.

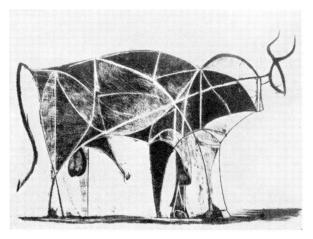

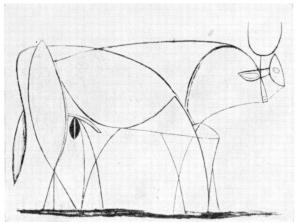

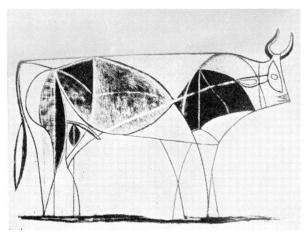

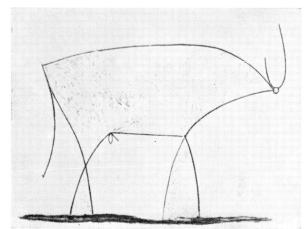

163

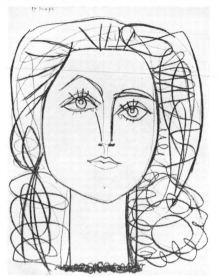

Woman's head Pablo Picasso. Lithograph.

Carmen Antoni Clavé. Colour lithograph.

Rider Marino Marini. Lithograph.

Study sheet with heads Pablo Picasso. Lithograph.

Rue du port, St Tropez Erich Rhein. Lithograph.

Composition 1949 Joan Miro. Colour lithograph.

Abundance of possibilities

The soft, tone-carrying chalk line, the harder stroke of the reed pen, and the traces made with a full or heavy brush create an infinite range of contrasting effects. These graphic and pictorial possibilities are increased by the varying degrees of roughness of the stone surface. Different textures can be achieved by pressing bits of material drenched in litho ink against the stone. On a stone dampened with distilled water graphic effects can be made with litho ink similar to those made with drawing ink on dampened paper. Petrol sprayed on the freshly drawn-on stone results in patchiness.

Picasso, Clavé and many other artists have handled lithographic techniques very unconventionally and, from the printer's point of view, rather unprofessionally. Sometimes large areas of a finely grained litho stone are simply painted freely with litho ink. Petrol, which creates a slightly pearly effect, is added to the litho ink for those areas where transparency is desirable. Grey, intermediary shades can be developed by grinding off parts with pumice stone or correcting-stone and water, and other effects can be achieved by scratching off the ink with a razor blade. Even brighter effects can be created by wiping the stone with a cloth dipped in petrol which will dissolve the ink either completely or partly. It is not always certain whether the intermediary shades will sustain the printing process and not close up. While working on a lithographic portrait of his children, Picasso dipped his fingers into the litho ink and placed them on the stone in order to get the grey dots he wanted. Stimulating graphic effects can also be achieved by scratching thin white lines with a sharp fingernail into the more darkly marked areas of the stone (see illustration on page 165, top right).

Resist drawing techniques

With lithographs similar effects to those of the spray paintings of the introductory graphic techniques or the resist drawings of the etching techniques can be created. In order to achieve this, a pen or brush drawing is made on the stone with diluted gum arabic, and when the stone is dry it is painted with litho ink or chalk in large areas. Further treatment of the stone by etching, washing, etc. (as described at the beginning of this chapter) will make the top layers, which were covered with gum arabic, crack off slightly. The gum arabic drawing will then print negative, i.e. on a dark background.

Modern Bust Pablo Picasso. Lithograph and resist technique.

Etched lithography

In the case of many lithographs bright strokes are scratched into the stone afterwards with an etching or engraving needle. Alternatively a heavy scraper, which tears open white dots, is pushed lightly over it. Strictly speaking, we have now gone beyond the limits of surface printing.

As with metal, it is possible to make dry-point, etched and aquatint-like etchings from stone—also in a mechanical or chemical way. Unfortunately these techniques are scarcely practised any more, despite the fact that the etched lithograph has the advantage of maintaining a pure tone which is not possible with etchings of copper and zinc. Choose highly polished, extremely hard grey or blue stones. Prepare the surface by painting it with a solution of gum arabic mixed with a small amount of gall-nut extract. The gum solution should be acid—nitric acid is possibly most suitable.

In order to get a highly polished stone surface, dissolve finely pulverized salt of sorrel in water, add some red haematite dampened with water and rub the stone with it in a grinding motion for some time.

The incision is made with a needle or a diamond. By impregnating the scratched-out lines with linseed oil, a soapy residue is formed, and this attracts the printing ink. The ink is not applied with a roller, but with a swab; a second swab is used for polishing. It is advisable to use a small amount of turpentine for the second polishing. The printing method is the same as for all lithographs.

Line etchings need an asphalt coating. With stone the depressions of the etched lines must be even, unlike copperplate etchings. In the case of copperplate printing, the printing blankets compensate for irregular depressions, but because of the hard pressboard surface this is not the case with stone.

Effects similar to aquatint can be obtained by spraying the grained stone with lithographic ink (using a brush and screen or a fixing spray-gun). Instead of using stencils, one can cover the parts intended to remain light with gum arabic and then spray over it (see illustration on page 167). After drying, the stone—which has been washed off with water—will show up the drawing. It is best to make any corrections after etching,

because unlike chalk it is possible to draw with ink on even a slightly etched stone. After this it is etched once again.

Transfer printing

Lithographed drawings can be transferred from stone to stone and from paper to stone. Transfer printing is a method of transferring a litho drawing made on stone on to the so-called printing stone intended for the printing of impressions. It is, of course, possible to print from the first stone; a transfer print on to the printing stone is undertaken if you want to preserve the original stone or if better exploitation of the printing surface would be achieved by means of the printing stone. The agent for the transfer print is a specially treated transfer-paper, which is *not* drawn on. This paper is treated with a layer of starch paste and is available in art shops.

From paper to stone

You draw on transfer paper with litho chalk or ink, just as if it were stone. If you wish to create the impression of a grained stone in your drawing, you could put a firm sheet of coarse drawing paper under the thin transfer-paper.

The polished and grained stone is wiped lightly with pure water; the transfer-paper is then carefully put over it, and pulled through the press a few times, stretching it just slightly. After you have made sure that the paper sticks in all parts, dampen it slightly and pull it through again a number of times. Repeat this procedure until the drawing has been transferred completely on to the stone; you can make sure of this by lifting a corner of the sheet of paper and checking the absorption of the drawing. With some types of paper the drawing will show up well on the back. Take care not to dampen the paper too much, as the layer of paste could soften prematurely and dislodge the paper from the stone. The pressboard must always be well greased. The inked pad should be turned round during the process, as a damaged spot would leave marks.

When the coating has been completed, the stone should be cleaned thoroughly,

dusted with talcum powder and very slightly etched. Should any corrections be necessary after the first proof, the acid must be removed from the stone, and for this alum and wood vinegar are used. When additions have been completed, you have to etch and gum once again. After washing out, the printing process can begin.

Chalk drawings can be printed quite well even from untreated paper. A thin but firm piece of paper should be used for this. Before pulling it through it must be painted on the reverse with a thin coat of nitric acid. The grinding is left on the stone as a protection. When it has been fixed in the press, methylated spirit is poured over the stone and lit. This procedure is repeated a few times until the stone is quite warm. The drawing is then placed on the stone, which by now will have been washed and dried again, and on top of this is placed a sheet of paper soaked in turpentine. You then have to work very quickly in order to avoid too much turpentine evaporating. After the whole thing has been pulled through the press with a great deal of evenly applied pressure, the picture is at first only faintly recognizable, and the drawing has to be rubbed in.

This is done in the following way. When the stone has cooled down it is dampened with thin gum. A small soft sponge moistened with litho ink and a small amount of washing-out tincture is rubbed gently and regularly over the stone. Gradually the drawing will appear. Fainter areas can be rubbed in for longer in order to bring them out more strongly. Should the stone dry too quickly, it should be gummed again. Always remember to finish up with the rubbing-in sponge. Then dry, dust with talcum powder, etch and then dry the stone again. Afterwards, wash it out with tincture and roll the ink on. After a few prints the drawing will improve and show satisfactory results. Should any additions be necessary, the same procedure is repeated.

It is also possible to print from ordinary writing paper; this is written on with autographic ink and then placed between damp (not wet) pieces of scrap paper for ten to fifteen minutes, and the printing stone wetted directly with turpentine. The written or drawn on paper is put with the damp, scrap side on the printing stone and pulled through the press with a certain amount of pressure. This is followed by the removal of the paper from the printing stone and the subsequent treatment of the stone—as already discussed—to obtain perfect impressions. Despite the startling effects, artistic objections are not altogether unjustified. Although it is often difficult to detect, there is, in fact, a difference between a straightforward lithographic drawing and a proof taken from transfer-paper.

The transfer printing technique from paper to printing stone undoubtedly offers a number of advantages and is much more convenient; stones are not easily transported and cannot be carried about in the same way as sketch books. In theory an exact reproduction of the lithograph should always be the result if the procedure described is meticulously followed. None the less, artists prefer drawing directly on to stone instead of paper. Smooth or coarse-grained stone is an ideal drawing ground which no type of paper can match. Even if the transfer is perfect, something of the original drawing will be lost. The grain of the paper and that of the stone are never completely identical. The most beautiful method of reproduction will always remain an impression of the original drawing made directly on stone.

From stone to stone

The treatment of the lithographed stone is the same as usual, but transfer printing ink which is particularly greasy, is used. After the ink has been rolled on to the stone, it is dried with a wind-flag or a hair drier.

Now the transfer-paper, which is treated with a layer of adhesive, is carefully placed on it, and on top of this a layer of soft scrap paper. This is then run through the press. The transfer-paper now shows the drawing, which was reversed on the stone, correctly.

After the treated printing stone has been dampened evenly with a sponge, the transfer-paper is placed on top of it, pressed down and, stretched tight, run through a transfer printing press. The paper is then wetted so that it can be pulled off easily. Provided that everything has been handled carefully during the transfer printing, the drawing to be printed is now clearly visible on the printing stone.

Camels Algraphy; surface printing method from an aluminium plate.

172

Printing from metal plates and offset printing

Printers who today carry on the tradition of stone printing (lithography) do not in fact use stone for this purpose except in very rare cases, but zinc plates. For particularly demanding artists' prints, however, stone has not yet become obsolete. The Parisian master printer Mourlot, from whom Picasso, Braque, Matisse, Chagall, Raoul Dufy and others learnt the art of lithography, owns a vast library of stones, some of which are up to eighty years old; and he still prints from stone. Although Mourlot uses modern machines to grind them off, the treatment of the lithographic stones—especially the graining, etc.—is still done by hand. Zinc plates are, of course, much easier to transport, handle and store. Zinc and aluminium plates are ground and grained rather like lithographic stones. They are also drawn on with litho chalk or ink, and are then etched, dried, and rolled. Individual proofs can be run off a copperplate press due to the low weight of zinc and aluminium plates. Pen and ink drawings can be reproduced almost more easily from zinc or aluminium than from stone. In the case of aluminium, the etching is done with phosphoric acid.

Even pencil drawings can be printed from zinc. One pours hydrochloric or nitric acid over a finely grained zinc plate, then bathe it in it, rinse the surface well, wash off the mud which will have formed and dry the plate quickly. One can now draw with negro-pencil or koh-i-noor pencil on the metal plate just as if it were paper; it is even possible to make corrections with a rubber eraser. Finger prints must, however, be avoided.

It is then etched (for half a minute), washed, gummed and dried. After the gum has been washed off again, the ink is rolled on the plate till every stroke of the pencil drawing has taken the pigment.

Offset printing developed from lithography. The form is a grained zinc plate with the typical qualities of stone; zinc plates cannot, however, be corrected like stones. The zinc plate is wiped and inked; during the printing process the ink is first transferred on to a rubber sheet, and then on to paper. This is, therefore, an indirect printing technique, as opposed to the direct method of the lithographic machine press. As the drawing is usually transferred photomechanically, offset printing is mostly found in the sphere of commercial art, which aims at a high number of printings, rather than in the sphere of the manual graphic arts (i.e. artist-produced prints).

Test stones Robert Rauschenberg. Silk-screen
print. By kind permission of Gemini G.E.L. © 1971.

Screen printing, serigraphy, silk and organdie printing

Serigraphy, also called silk-screen printing, is strictly speaking not a printing technique
but an improved method of stencilling in which paint is brushed over a finely meshed
net or screen. It has only recently been adopted into the family of printing techniques

and quickly acquired many followers, especially amongst designers. Those parts of the drawing which are supposed not to show are blocked out by painting a layer of glue or lacquer on to the stretched-silk, nylon, bronze or steel screen. The screen is stretched over a wooden or metal frame and is then put on a paper or material surface and special impasto colouring matter is pulled over it with a squeegee. The colour only penetrates those parts of the screen that have not previously been blocked out. The screen ink to be used should contain a different type of binding agent from that of the lacquer, so that the mask does not dissolve.

Stencils

Masking or glue stencil The simplest demonstration of a screen print is a brush drawing on the screen with paste or water-soluble glue. Cover the drawing with a transparent material (Cellophane, foil or something similar) and place it underneath the screen. Block all those parts not intended to print with water-soluble glue or paste, printing when it is dry. Screen ink pulled on with a squeegee will only penetrate the pores of the screen around the water-soluble glue drawing. The result is a negative impression of the design.

Washable stencil Alternatively, a grease drawing (either a lithographic crayon or lithographic ink drawing) can be drawn or painted on to the screen. On completion the screen surface is coated with screen glue, which will be repelled by the wax drawing. After drying, the grease drawing is removed with turpentine. The printing ink will now penetrate the screen in exactly those parts where the design was placed. The result is a positive impression of the design.

Paper stencils A further variation is to stick cut-out paper stencils under the silk or wire net and squeegee the pigment through on the open parts of the screen face.

Cut-outs are used frequently in screen printing because they reproduce prints exactly and commercial artists can make the stencils themselves. For their application it is best to use commercially sold stencil paper, which consists of two sheets of paper bonded together, the actual stencil paper and a sheet of backing paper; the latter holds in place loosely moving stencil parts, for example the inner shapes of the letters A, B, D and O, until the stencil has been fixed to the screen fabric. After the stencil paper has been evenly painted twice, the drawing or lettering is cut with a knife in

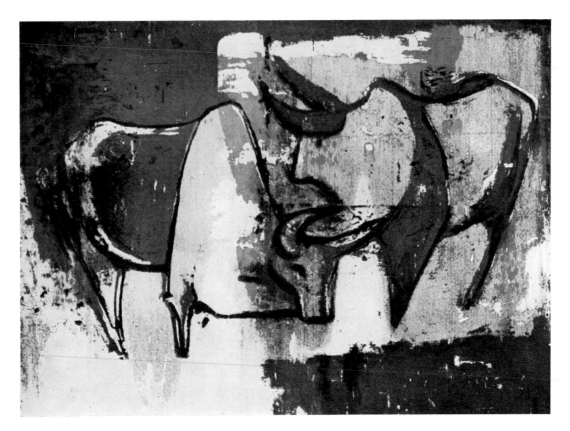

Cows Silk-screen print in three colours.

such a way that only the lacquer film and stencil paper (not, however, the backing paper) are actually cut through. The parts of the stencil representing the open or printing areas of the screen are peeled away from the backing material and the stencil shapes transferred by ironing from underneath with a warm iron, which causes the lacquer to melt slowly. Finally the backing material is removed, leaving the stencil.

Photographic stencil, direct and indirect method We shall refer quickly to this method of non-manual transfer of a drawing on to a screen, as it bears a similar relation to the manual printing techniques as the reproductive graphic techniques do to the actual artist-produced printing techniques. The equipment necessary for this method is expensive, but it does ensure that the most delicate of drawings can be accurately printed.

Direct photographic stencil The surface is prepared by painting the fabric with gelatine mixed with bichromate or a proprietary brand, which must be allowed to dry in the dark due to its sensitivity to light. With an arc or nitraphot lamp the drawing, which was made on a light pervious ground—or a transparency of it—is printed like a photographic print. As a result of the printing, only those parts of the gelatine layer which were not drawn on will harden. The soft parts which were covered by the drawing can be removed by subsequent developing and rinsing with warm water.

Indirect photographic stencil This method enables one to produce sharper prints. In this case the gelatine layer is applied to the fabric, which should be silk and not metal gauze, only *after* the treatment of the stencil has been completed. So-called pigment paper with a dyed gelatine layer is used for this method. There is a dry and a wet method, but to outline them would go beyond the scope of this book.

Preliminary drawings Sketches for colour silk-screen prints can be made with tempera colour or pastel chalks. If possible, the colours for the sketch should be chosen so that the visual effect corresponds with the consistency and transparency of the intended colour mixtures, which are obtained by printing one colour over another. This often results in startling effects (see illustrations on pages 178–79).

Overprinting The individual phases in the example of Wendland's screen print, *Town with Star*, show the separate colour areas more clearly. This is a six-colour print which in fact was created with only three screens. The first screen printed only black, the second red, yellow and blue, and the third a very gentle light-blue and pink.

Figure A illustrates the black print (the first printing stage), and figure B (black and red) shows the second printing stage. In the third stage (not shown here) blue was over-printed, and in the fourth stage yellow; the result is illustrated in figure C. The same screen was then used to print the fifth colour, light-blue, which appears here in figure D on white; in reality, however, it was of course printed over the fourth stage, figure C. Pink was printed with the same screen over the fifth stage, and the resulting sixth stage represents the finished picture (see page 179).

It should be mentioned that although the same screen was used for the last two printing stages of light-blue and pink (a combination of glue stencil and paper stencil),

Town with star Gerhard Wendland. Screenprint.

variations were created by partially masking parts with thin paper, so that pink and light-blue did not always cover each other; otherwise they would not have appeared as pure colours anywhere in the picture.

It is worthwhile studying various areas in the picture to find out how the different basic colours resulted in such startling colour combinations. The colour results created by printing black on light grey are also very interesting.

The printing of the three colours red, yellow and blue was done in a similar way, as otherwise no pure red, yellow or blue would have appeared in the final result.

Fabric printing

If one wishes to print on fabric, one has to treat the material first in order to remove the starchy stiffening agent. This can be done by soaking the material for some time and then rinsing it in water to which a small amount of washing soda or malt extract has been added. When the fabric has been rinsed again, it is dried and ironed. Fabrics are often printed by serigraphy on copper net with helizarin dyes.

Advantages and disadvantages of screenprinting

In general screenprinting is only suitable for patterns and drawings larger than 20 cm to 25 cm (8 in to 10 in).

One great advantage of screenprinting is that no complicated machinery is needed and there are no plate costs. It also allows great scope as regards the design. One can print on all kinds of material (wood, tin, glass, etc.) and it is possible to print plastically, which is not possible with any other printing method.

For smallish print runs of posters, fabric prints, etc., screenprinting, and particularly colour screenprinting, is the most suitable and economical method. For larger print runs screenprinting is not always worth considering, as the amount of colouring matter needed makes it expensive. Incidentally, regard should be paid to the fact that thick cut-outs also result in thick layers of colour.

Quite a few artists and commercial artists have set up their own screenprinting workshops, and a number of schools teach silk-screen printing in art lessons in the upper forms. Apart from poster and fabric prints, screenprinting is also a suitable medium when purely visual effects are to be created.

Alphabet Jasper Johns. Lithograph. By kind
permission of Gemini G.E.L. © 1971.

Homage to the square Josef Albers. Screenprint.
By kind permission of Gemini G.E.L. © 1971.

Lithograph. Jasper Johns. By kind permission of
Gemini G.E.L. © 1971.

Star of Persia Frank Stella. Lithograph. By kind permission of Gemini G.E.L. Ⓒ 1971.

Mixed media

Order is the desire of reason, but disorder is the delight of fantasy.
Paul Claudel

'Rules and laws are good for weak hours; for the strong hours we don't need them', said Thomas à Kempis. Regulations are only of limited value. Both the expert and the amateur are tempted to branch out from prescribed limits; the expert longs for the unknown, the amateur hopes to be surprised by new things, they both want to create new combinations, to translate and use newly gained experience for their own artistic ends. The possibilities are limitless, and here I shall only point out a few combinations taken from my own experience. The headings at the beginning of each of the main sections of this book—relief printing, intaglio printing and surface printing—indicate the typical aspects of, as well as the differences between, these three main printing techniques. But interesting results can often be created by interchanging the methods; for example, by rolling ink over an etching plate intended for intaglio printing, instead of dabbing it on. Fine white line drawings, giving an impression of great simplicity, can result from a relief impression taken from an intaglio line etching (see illustration on page 187, bottom left). Afterwards aquatint tonal areas were created on the same plate and were then printed by the intaglio method (bottom right).

The illustration on page 186 is an aquatint etching which was printed by the relief method instead of the intaglio method resulting in an exchange of tonal values.

It is more difficult, however, to print blocks and plates intended for relief printing by the intaglio method; nevertheless, the so-called lino-etching is an example of this. Instead of a white-line proof, which is easily produced from a lino-cut, we get a black-line proof. A black-line cut from a lino-plate would be more difficult and laborious to make. It would also result in totally different proofs from those printed by the intaglio method, in which the lino receives the printing ink in a similar way to that described in the chapter on etchings.

A further combination of manual surface and intaglio printing techniques is to be found in etched lithographs. Here a whole area of the stone intended for surface printing

is blackened with lithographic ink and then a white-line drawing is scraped out with an etching or engraving needle or a steel point, in the same way that white lines are created in the relief technique of wood engraving. A number of modern artists have employed this technique, and some have also combined it with other methods. If the black area of a lightly grained litho stone is lightened by careful treatment with the scraper—that is, if a number of moulded lights or decorative areas are scraped out of it—then one can say that this technique has in fact been taken over from the mezzo-

Circo Espagnol Aquatint printed as relief.

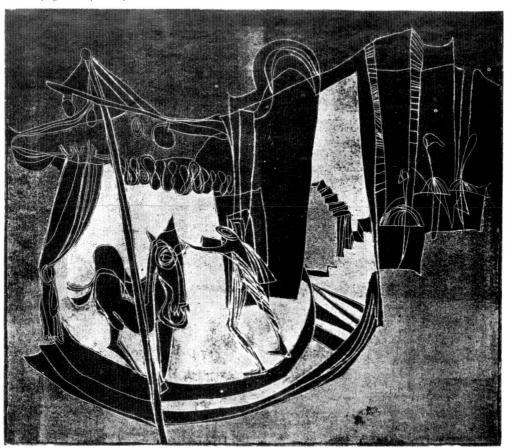

tint process on grained metal plates. There are also combinations of fabric prints and woodcuts. Combinations of fabric printing, spray painting, resist drawing (the latter being used with gum arabic), in fact of almost all the introductory graphic techniques can be achieved by means of lithography. In the case of the litho-string print, for example, string is dipped into lithographic ink and an impression made of it on the stone, which is then treated just like any other lithograph.

An interesting transposition can be seen in the lithographs *Gipsy Children* and *Dutch Child with Doll* (four illustrations on pages 156–59). After the drawing has been made on the stone using a reed pen and chalk, scraps of curtain material dipped in lithographic ink were used to draw the blouse. Then positive impressions were run off. The stone, which had previously been covered with printing ink, was then etched with hydrochloric acid for the relief printing method. A broad leather roller was used to roll the greasy printer's ink on to the dry stone, and this blackened everything almost completely. As the drawing was in a slightly raised position, the roller did not touch the dry stone at the edges of the lines of the drawing. Around the black lines and patches in the 'blind spot', strange white 'forecourts' were formed with borders gently petering out. However, only a limited number of prints could be run off the stone in this second state.

When the strange white lines and patches had unfortunately disappeared after a few impressions and the picture had grown black, the drawing was carefully smoothed off

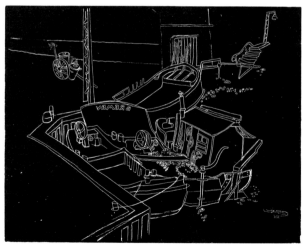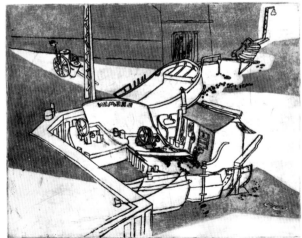

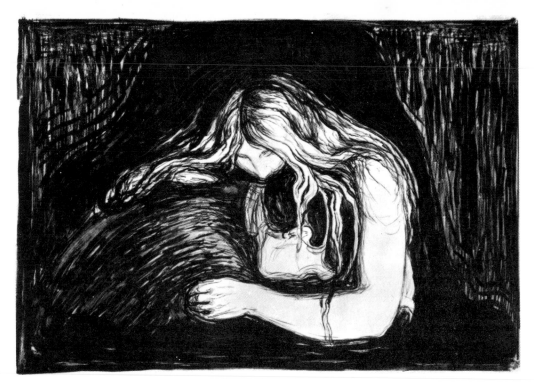

Vampire Edvard Munch. Lithograph and woodcut combined.

so that it emerged as a strong white. This interesting new variation is not shown here.

Amongst the introductory graphic techniques the colour monoprint from an etching plate and from a lino-cut can be classed as a mixed media technique.

A good painter uses colour sparingly. There is no doubt that with graphic techniques too, a restricted use of technical means and conscientious attention to the requirements of craft—especially in the production of the picture base (plates, blocks, stones, etc.)—are commendable virtues, particularly in the inexperienced. At the same time, however, inhibition can deprive a work of art of its liveliness. One must have the confidence and resolution to be prepared always to attempt something new and challenging.

From the free graphic arts to commercial art

We consider the isolation to which the literal arts have been reduced and their estrangement from creation to be the most ominous heritage of a passing age.
Hans Schwippert

Commercial graphic art is a specialized field which includes not only the general art subjects, but also those of lettering, applied lettering, advertising techniques and other subjects. A number of independent painters and graphic artists also apply themselves to commercial art.

Both the decorative arts and commercial art have been greatly influenced by the graphic techniques of independent artists. Since Toulouse-Lautrec, well-known French painters and graphic artists have employed their skills in the field of commercial art. Apart from their pictures and prints, Bonnard, Matisse, Braque, Picasso, Chagall and Clavé created posters, book-covers, illustrations and invitation cards of great artistic value. Progressive artists and teachers of art therefore claim that the aim of art-schools should not simply be to train specialists, but to further those who will later take an active part in forming our environment. The graphic techniques, in particular, play an important part in inspiring and influencing fabric design, decorative painting and commercial art in general. This is borne out by many of the illustrations in this book.

As far as invitation cards, prospectuses, advertisements and packaging are concerned, typography is of great importance, and in conjunction with graphic techniques one can experiment with startling effects. The typographer can learn from the graphic artist, and the graphic artist from the typographer, if both are receptive to new ideas and search for a high degree of quality in their own artistic field. Like the gentler and finer visual effects of an etching or the small, subtly drawn lithograph in broken colours (ink or chalk, for example), this type of graphic art will be most suitable for illustrations or vignettes. A large, strong stencil, wood or lino-cut usually has the right qualities for a poster. The object advertised determines not only the most suitable technique, but also the appropriate typeface.

When uniformity of the technical and formal elements is desired, as opposed to a marked contrast, it is often advantageous to draw, paint, stencil, cut, write or spray the lettering to correspond with the particular technique of the picture motif, rather than set and machine-print the type. It is often the case, however, that a poster can still contain a certain general uniformity and yet profit from these contrasting elements. For this reason, in compositions containing both illustration and lettering, contrasts such as small / large, calm / turbulent, soft / hard, crowded / uncrowded, dark / light or colourful / colourless are consciously played off against each other. A composition is well-balanced when nothing could be added or taken away without spoiling the general impression. An empty space can often be meaningful, and the Japanese were particularly good at exploiting this. It would be going beyond the scope of this book to give rules or even instructions as regards commercial art. I shall only mention a few technical hints. The lettering and illustration should already be composed to form a whole in the first couple of sketches. It is often advisable to use the montage technique with cut and torn pieces of paper, lines of type, etc., which can easily be brought into just the right proportion by moving them about after a variety of possibilities have been quickly tried out. A sheet of glass over the various pieces of paper will flatten the surface and dispose of distracting shadows. One can also draw the lettering, lines or special areas on glass or transparent foil and use this to find the best arrangement on the design underneath. Instead of giving long theoretical instructions, which do not really illustrate anything, I have selected a number of works by artists and art graduates developed from the principles of free graphic art into commercial art.

Collage applied in art-teaching.

191

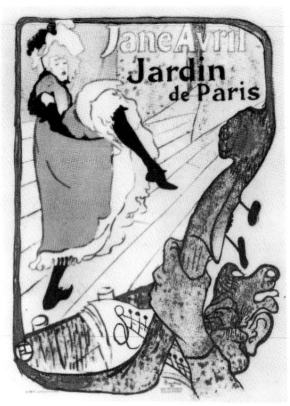

Henri de Toulouse-Lautrec.

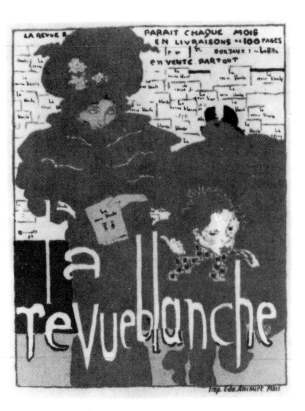

Pierre Bonnard.

Title woodcut. Ernst Ludwig Kirchner.

Candide Antoni Clavé.
Lithograph.

The importance of graphic techniques with regard to art-teaching

Perception is the basis of all knowledge.
Pestalozzi

Graphic techniques offer an ideal means of training in sculptural awareness, and the illustrations in this book should, therefore, be of use to both art teachers and pupils. If a young child produces pleasing results and thus confirms the achievement of art-teaching, yet later has difficulties as far as design is concerned, I would draw the teacher's attention to the importance of the graphic techniques for mastering this type of problem. This has not yet been fully recognized and exploited. In all types of schools and art colleges plenty of scope should be given to the teaching of graphic techniques, which are of great educational value for the following reasons:

1. They demand an intensive study of shapes.

2. They help to create an understanding of the possibilities inherent in raw materials, and of the use of tools; they therefore further knowledge of technical means and create an awareness of style in relation to working materials and craftsmanship.

3. They offer variety, encouragement and often exciting surprises.

4. They stimulate experimentation and the imagination.

5. They allow for reproduction and all sorts of variation; here it should be pointed out that comparison is usually the best form of art appreciation.

6. The variability of their creative treatment allows a choice suitable to the particular motif, and also to the creative will and individual character of the artist.

7. The peculiarities of the graphic techniques—when selected and used correctly— can provide an excellent stimulus for the art student if he has come to a standstill.

In this way it is possible to correct, according to the choice of technique, a careless or struggling worker, and to engage those mainly interested in the technical aspects of art. Formal knowledge takes on a new life, and dangers of rigid formalization or style can be treated effectively.

For example, the artist who perhaps models in too plastic a way might find that exercises in stencil printing, spray painting and aquatint affirm for him the possibilities of surface creation.

For the artist whose shapes are too soft, exercises in the techniques of dry-point etching, the etched line and the end-grain cut would force him to use definite shapes.

For the pedantic calligrapher, woodcuts, verni mou, aquatints, lithographs on a grained ground with chalk and resist drawings might open up unconsidered and totally different ways of expression.

All the possibilities within the scope of art can be tried out. The idea is not simply to create a pleasant change or to follow some kind of sensationalist line, but to come to realize the variety of graphic methods which are interchangeable amongst themselves as well as with the independent exercises in the fields of drawing and painting. This knowledge is just as valid for the painter and the commercial artist as it is for the art student and the art teacher. For economic reasons too, graphic art (and in this case commercial art in particular) is very valuable for the artist as well as for the art lover. Works of graphic art may be bought fairly inexpensively as originals, and many examples of commercial art help in the shaping of one's environment. There are excellent contemporary works of art which would be suitable for creating an understanding for modern art and design.

Fabric printing block from Achmim (Egypt), 4th
century A.D.

A look at history

One should behave towards a work of art as one does towards someone of high position. One must wait until one is called.
Schopenhauer

The beginnings and the early period of the woodcut

A history of the graphic techniques should really start in prehistory. The cave dweller who dipped his hand into animal's blood and pressed it on to rock made the first relief monoprint.

Printing on paper began in China with Ts'ai Lun in 105 B.C. The oldest known examples of fabric printing on cotton, linen or silk can be traced back to the sixth and seventh centuries B.C. Wooden stamps manufactured by the Chinese in 230 B.C. and the Roman *tesserae signatoriae*, which were also used for printing, were the predecessors of the woodcut. The Japanese are said to have cut figures in wood in the sixth century A.D., which they used in combination with colouring matter to impress stamps on paper. The oldest pictorial woodcut is supposed to be the cover picture of a Sutra which was found in Tunhuang and carried a date equivalent to our year A.D. 868. Only many centuries later did Europe follow step. At the beginning of the 14th century textile printing seems to have been introduced here. According to Elfried Bock, printing on fabric has been known for a thousand years. Wood-blocks were used for this purpose. With the exception of the wooden stamp prints, the *Holy Christopher* of 1423 (see page 78, right) could be regarded as the oldest example of the European woodcut—a highly rated artistic achievement. Apart from this, the earliest cuts are mainly outline drawings coloured by hand. In any case the printing of drawings and pictures was possible long before Gutenberg succeeded in reproducing the written word with movable type. Even after this invention, the picture woodcut continued to be used as a welcome means of illustration. The so-called block-books, which were illustrated with picture prints, owe their name to the comments in the text, which first of all were cut together with the picture cuts as letter tapes and finally into separately cut blocks.

These block-books were extremely popular. Many were re-cut again and again; they even survived for some time when books printed in movable type were illustrated with woodcuts. They did, of course, become superfluous once it had become possible to establish a satisfactory connection between book-printing and picture printing.

The early pictures of saints may be naïve, but they express great faith and strength. Their pictorial language is intense and symbolically meaningful. This is also true of the painters of playing cards in 15th-century Augsburg, of the Ulm cuts, of the block-cutters in other parts of Europe, as well as of all the wood engravers before the time of Dürer. In the early days of woodcutting caution and a certain clumsiness often caused the lines of the chiaroscuro woodcuts to be rather unrefined. The pictures were limited to essentials with forceful and rough lines.

The development of the woodcut in Europe, Japan and China

Gradually patterns, structures, disposition of folds and later even three-dimensional hatching were added to the simple shapes. The surface-like quality of the European woodcut developed first of all into a relief impression; then spatial depth (perspective) was added, and during the Renaissance figures become more plastic and anatomically more correct. Improved technical ability and more natural views as a result of the influence of the natural sciences had startling effects, but all too frequently this progress was paid for at the expense of elementary expressiveness. The Far East, however, has remained loyal to the inherited artistic theory of shape up to the present day. The Chinese and Japanese aim for pure surface effects without plasticity, light or shade; they cultivated and developed the composition throughout the centuries, restricting it strongly to simple lines and black and white surfaces. The fact that the woodcut has always remained the ultimate graphic technique in the Far East is at times put forward as a reason for this, as is the fact that the copper engraving, which could have tempted the artist to become unfaithful to the woodcut, existed in neither Japan nor China. In Europe, the desire for technical refinement on the other hand, was met in the 15th century by engravings in white on stippled background; here an instrument similar to the burin and punches dug points, furrows and hatchings into the wood which, when printed, appeared white. Dürer and his successors imitated some of the effects

typical of copper engravings in their woodcuts. The so-called prime of German graphic art (Dürer, Holbein, Cranach, Schongauer, Altdorfer, Aldegrever, Baldung-Grien, Burgkmair and Beham) coincided with the time of Gutenberg's invention. Since the 15th century graphic art has been an important branch of art.

Wood engraving

When in approximately 1770 the English copperplate engraver Thomas Bewick succeeded in creating on wood pictorial effects similar to those on copperplate, and invented the wood engraving on end-grain timber (boxwood cut across the grain), the woodcut started to decline as an art form. There is no doubt, however, that the woodcut has produced technically remarkable achievements.

In the 19th century the woodcut and wood engraving were frequently used to illustrate mass-publications. Bewick's invention of the wood engraving brought with it a new range of shades. The tone cut based on the white-line engraving developed, and this made it possible to reproduce pure tonal effects. From the artistic point of view, however, the wood engraving competed more and more, and rather unfavourably, with the style of the copper engraving and the etching. The block-cutter was regarded by the artist who took over the design as an inferior operator. He had to give in to all the artist's whims, however much they went against the rules of woodcutting techniques. This resulted in an alienation from craftsmanship and a decline in the feeling for a work style.

Artistic evaluation of xylography

The artistic re-birth of the woodcut and wood engraving in recent times has still to be discussed. In his book *Woodcut, Wood Engraving* (1947), Imre Reiner, the Swiss graphic artist and wood engraver, calls the woodcut the old technique and the wood engraving the new technique—in order to make a clear definition, not just for the

sake of criticism. There has always been a technical difference between woodcut and wood engraving. The much more important question, however, is whether prints can be classed as originals by a particular artist, or whether they are just facsimile woodcuts or engravings by a professional wood engraver. Imre Reiner defends the wood engraver who, in his capacity as a pure craftsman, helps the artist working within the confines of the medium. Dürer was not in a position to cut most of his woodcuts himself; he and many of his successors delegated this task to experienced craftsmen. Holbein, for example, worked with the outstanding block-cutter, Hans Lützelburger. In the 19th century a good working relationship between artist and wood engraver still existed. It is not necessarily a sign of decadence if the wood-block is cut by an engraver, assuming that the artist and the wood engraver work in harmony. When it became possible to transfer pictures photomechanically on to a block, wood was displaced by chemigraphy (the metal etching process). Although the 17th century supplied us with a rich harvest of wood engravings and woodcuts, nothing in Europe at that time can equal the works of Japanese masters like Utamaro, Moronubu, Morikuni, Suzuki and later Hokusai and Hiroshiga.

Hand-printed wallpaper

The history of hand-printed wallpapers has already been discussed to some extent (see page 95). Plinius made mention of prints on wall coverings in classical times. Ancient Persian Sassanian art was most imaginative and, via Byzantium, this influenced the artistic work of medieval Europe. During the Gothic period and the early Renaissance artists were fond of covering plain walls with painted reproductions of patterned and printed fabric coverings. Even expensive parchments with stencilled ornamentation were occasionally to be found; painted and varnished leather papers were also used, particularly in Holland. Hand-painted silk coverings were sometimes found in castles; more frequent, however, especially in the 18th century, was the decorative, usually multicoloured fabric print. Printed wallpaper, which was known in China in very early days, was introduced into Europe much later. Hand-painted wallpapers were first produced in the second half of the 18th century in France; hand-printed wallpaper on separate sheets was introduced in England. The first tapestry papers were produced as grisailles, and later were also multicoloured. Decorative motifs were followed by landscapes and figure compositions, selectively chosen from all the various art styles.

Art nouveau started a reform action furthered by German, Austrian and Swedish workshops for design and craftsmanship and the Bauhaus school, which created wallpapers of two-dimensional structure and a flat pattern. This was usually achieved by a design of light, intangible and hardly perceptible abstract shapes. At the same time the tapestry paper experienced a revival.

Copper engraving

Even in ancient times it would have been possible to print from engraved metal plates in the same way as from wooden stamps and woodcuts (also from low reliefs). The first engravers were goldsmiths, who, as we know, already existed in antiquity. But copper engraving only really began when pictures were carved on metal plates for the express purpose of printing from them. This was done when people wanted to reproduce models for goldsmiths and architects, playing cards and illustrations for religious subjects. In the most important European civilized countries this took place shortly before the middle of the 15th century. The oldest copper engravings known to us come from Germany. The most creative and influential engraver before Schongauer was the Master E S (so called from the initials on his engravings), a goldsmith from the Rhineland in 1440. Martin Schongauer, one of the most important copperplate engravers, was a painter and son of a goldsmith. The grotesque, coarse engravings of the sculptor Veit Stoss lead towards Dürer and his school; in fact almost all the masters of wood engraving and woodcut during the prime of German graphic art also worked with copper engravings. Even though there were no copperplate engravers of outstanding importance among Dürer's contemporaries, there were a number of popular artists called the 'Little Masters' after their small-sized engravings. Bartel and Sebald Beham, who made early use of the etching needle, are particularly famous copperplate engravers.

Etching

Engravings in metal already existed at the time of the Etruscans. The niello can be regarded as the graphic predecessor of the copperplate etching; this was an en-

graving in metal produced in the Middle Ages in which engraved lines were filled with a dark fusible mass (a mixture of lead, silver, copper and sulphur). It was used by goldsmiths and armourers and was probably an oriental invention.

Copperplate etchings based on the etched line, which might be classed as the most significant graphic method as regards copper, were developed between about 1470 and 1500. One of the first artists to employ corrosive acid for creating recesses in drawings on metal was Daniel Hopfer from Augsburg. A few years later (between 1515 and 1518), Albrecht Dürer turned his talents towards the art of etching.

Augustin Hirschvogel is counted amongst the earliest known landscape etchers and in Italy Mantegna made masterly use of the burin and needle during this time. The greatest 17th-century etchers in France were Jacques Callot and Claude Lorrain. Abraham Bosse wrote a treatise on the art of etching in 1645.

During the Thirty Years' War a German gentleman-in-waiting, Ludwig von Siegen, invented the scraper technique in Kassel when he created the first mezzotint engraving. He augmented the usual line drawing of that time by creating highlights on a roughened copperplate and completing them with a burin. The mezzotint process was particularly famous in England—especially in the 18th century. William Hogarth was considered to be the best painter-engraver, and Green, Smith, Watson, Murphy and Watt were outstanding exponents of the mezzotint technique. The great significance of 17th- and 18th-century Dutch painting must also be viewed in the light of the graphic art of Rubens and the copperplate engravers of his school, as well as those of the great engraver van Dyck.

The significance of Rembrandt in graphic art

Rembrandt's art reached beyond narrow national boundaries and marked the beginning of modern art. He portrayed everything and, with his moving, personal genius, made it all vital, visionary and universally valid. In his compositions he masters the problem of light and shade and anticipates both impressionism and expressionism. It is moving and both psychologically and technically interesting to follow his struggle for ultimate expression in his prints.

He was completely self-taught and intuitive as far as etching was concerned. Far ahead of his time, he created a completely new mode of expression. Even today his etchings seem artistically and technically so up to date that one might easily believe them to have been created only yesterday. Almost all the great artists since his time have learnt from him, from Goya to Picasso, Rouault and Chagall.

European etchers—new techniques

Elsheimer and the architectural etcher Matthäus Merian the Elder, who produced in a somewhat sober etching technique a number of illustrations of the Zeiler topography (views of towns), worked in Germany in the 17th century. Merian's daughter, Maria Sibylla Merian, was an excellent copperplate engraver and scientist; she travelled round Surinam at some time about 1700 and created beautiful works of art on exotic plants and the development of insects.

Italy produced Canaletto, famous for his etched veduta, and Tiepolo, whose etchings are highly esteemed today. In France the Watteau engravers of the 18th century developed their own school. Watteau's pupil, François Boucher, made etchings from his own designs and from the engravings of his master. Boucher's pupil, Jean Charles François, invented the crayon engraving in his attempt to translate Watteau's and Boucher's chalk techniques into a method of graphic reproduction. In Paris he was the *graveur du roi*. Watteau and the Dutch school also inspired the young Goya, though his actual work was very much his own creation. In Germany Chodowiecki was the only etcher to achieve world fame.

In the early part of its existence the copperplate engraving did not play an important role in art. The great painters at the time of Velásquez were not interested in printing techniques. Nevertheless, one of Spain's greatest painters, Francisco de Goya (1746 to 1828), developed a new technique, the aquatint etching. He became famous throughout the world with his etchings *Desastres della guerra*, the series *Tauromaquia* and the demonic *Caprichos* full of Gallic humour. After experimenting in his own workshop, Goya mastered the invention of the Frenchman Le Prince, which had been kept secret till then and had only just emerged in a publication of the *Encyclopaidie* in 1791, and achieved superb artistic effects. Heath invented the steel engraving in 1820.

Another technically interesting method, the *vernis mou* or soft-ground etching, was developed in particular by the French graphic artist, Felicien Rops (1833 to 1898). The European pre- and post-impressionists occasionally employed the etching in their work. The following were especially noteworthy: in France, Corot, Millet, Manet, Rodin, Degas, Gauguin, Picasso, Chagall and Derain; in Germany, Corinth, Slevogt, Liebermann, Meid and Orlik; in England, Whistler and Brangwyn; in the Netherlands, Israels, Ensor and van Gogh; and in Scandinavia, Edvard Munch and Anders Zorn. The majority of those mentioned were primarily painters who regarded the etching in the same light as all the other graphic techniques, that is as a supplementary aspect of their craft.

Lithography

In 1798 Aloys Senefelder invented the technique of lithography in Munich. Few artists and collectors know that printing from etched stone sprang indirectly from the much older process of copperplate etching. When the former law student and actor, Senefelder, wanted to find a way of printing his literary works cheaply, he tried to etch type in copper. He made various experiments, attempting to etch on pewter, and later on Kelheim lime slabs. Once he happened to draw up his laundry-bill on stone with covering paint and then tried to etch the letters drawn with greasy ink; it was then that he made the technical discoveries from which lithography developed.

It was the grained stone lithograph which created the lithographical technique's great success. Although lithography had numerous followers in Germany, it was the French artists, and in particular Daumier, who developed it to its unparalleled artistic and technical heights. He was joined in 19th-century France by Gavarni, Delacroix, Géricault, Ingres, Prudhon and Carrière. Amongst the German artists who devoted themselves successfully to the art of lithography were Blechen, Olivier, Schwind, Menzel, Krüger and Schinkel. At the very end of the 19th century Toulouse-Lautrec's lithographic posters and illustrations raised commercial art to the level of greatness.

The Impressionists were, understandably, extremely interested in lithography, as this made it possible to create fresh reproductions of hand-drawings true to the original. In France this applied to Cézanne, Picasso, Degas, Renoir, Manet, Bonnard and Gauguin; in Germany, Corinth, Slevogt and Liebermann.

Screen printing

The most recent picture printing method, silk-screen printing (serigraphy) which has been known in the field of textile printing for some time, is basically a method of stencilling. In America not only artists, but also commercial artists and fabric printers have employed the new technique for some time. Fabric printers first used the stencilling method in Japan, where artistically and technically perfect prints were achieved some time ago.

In the so-called 'Yuze-printing method', figures or lines were cut out of paper or cardboard. A pigment was then brushed over the stencil, which had been placed on cotton or crêpe material. As suspended stencil parts had to be avoided, the creative scope of the design was naturally limited. Besides this, paper or cardboard stencils softened and therefore did not last very long.

Some technical faults were eliminated by employing oiled card and metal stencils. Despite the use of such simple materials, beautifully delicate patterns were achieved. In order to create even better results, connecting cross-pieces had to be secured and certain parts stabilized. The Japanese sewed up exposed parts and joined freely suspended ones with untwisted silk threads or human hair.

Later on cardboard was no longer employed for the production of stencils and human hair was stuck on wooden frames instead. This was finally substituted by silk gauze, thus forming an integrated frame. Some Japanese dyeing stencils show a fine cobweb-like net of untwisted silk threads, which held two layers of paper in position and thus ensured that the stencil parts were not displaced during the work process.

Parallel with these technical developments, there were improvements in the production of dyestuffs. The achievement of sectional colouring with the help of thickened dyes forms an important aspect of fabric printing. The thickeners are supposed to both bind the liquids and stop capillary action in the fabric, as well as being washable afterwards.

In about 1850 the famous silk town of Lyon produced the first *Impremés à la Lyonnaise*, very popular and delicate prints, but due to the small print number also rather expensive. Around 1870 a number of stencil prints appeared in Switzerland and Germany, and in

approximately 1900 attempts at silk printing began in the U.S.A., where essential technical improvements were made in about 1924.

Soon afterwards screenprinting gained industrial importance, which spread its use at a surprising rate. Its appeal is mainly due to the fact that it can be used with all sorts of textures, materials and dyes, and that it allows for small print runs. Apart from fabric designers and commercial artists, it was also taken up by painters who used it as a means of colour printing.

Collage, montage and material printing

Although collage and montage cannot be classed as methods of printing, belonging to the category of introductory graphic techniques, they should still be included in our historical summary, as they play an important part in modern graphics.

Schwitters assembled his *Merzbilder* from torn bus or train tickets, newspaper cuttings, etc.; the word *Merzbild* can be traced back to the syllable *merz*, which was left over from the word *Commerz* (commerce) on one of his collage pictures. As early as 1912 Picasso and Braque included documents with block capitals, wood imitations and fabric remnants in their graphic compositions and paintings to make startling *papier collés*. Juan Gris, Arp, the Italian Futurists, the German masters of the Bauhaus and the Russian Constructivists created individual *papier collés*; Matisse developed exotic paper silhouettes. The illustration on page 37 shows a *Merzbild* by Schwitters.

Representational shapes can be seen in Max Ernst's surrealist *Collages*, which he began to assemble from photographs, paintings and parts of woodcuts in 1920. By interchanging normal proportions and joining them together in a bizarre way, he reflects an abysmal and demonic world, the world of the subconscious, of basic urges and dream visions. One of his most famous series, *Le Lion de Belfort* (see page 215), tells the story in various versions of the man of power who has degenerated into a beast of prey. Using the different origin of the woodcuts, wood engravings and copperplate engravings, contrasting methods are deliberately brought face to face.

Great artists such as Bosch, Grünewald, Callot, Brueghel and Arcimboldo are some-

times referred to. Removal into 'super-reality' is achieved by the type of photomontage created by the Master of the Bauhaus, Moholy-Nagy, which is sometimes interlinked with linear drawings in a technically frigid style. Amongst other things, they have had a great influence on commercial art.

Out of a montage of wires, wire-mesh, lattice-work, tin strips, perforated and punched tin parts riveted or soldered on to metal plates, Rolf Nesch developed a genuine print-making technique, the material print. Here the graphic attraction is often enhanced by the embossed print.

In modern art we also meet, apart from montage and collage, the terms *papier collé* and *papier découpé*. The collage allows for chance and the incorporation of all types of materials; *papier collé* elucidates a particular intention; *papier découpé* stresses the outline, in other words the drawing as such.

Graphic art since 1900

Screenprinting, collage and material printing have all only become part of the graphic arts during this century, and they all played an important role immediately upon being introduced. However, even the oldest manual printing methods are still practised today and have acquired new significance through the work of present-day artists.

In 1889 the wood-cutter Linton remarked, in his thesis published that year, that the woodcut could only be saved by artists taking up the craft of woodcutting again. Those were prophetic words, but things in fact developed in a different way. In expressionist graphic art the interest came to centre on the woodcut in long-grain timber. It had to be newly conceived, and forced the artist to concentrate on simplified outlines and definite black-and-white effects, he also had to take the structure of the material into consideration, which resulted in a more intense expression and immediate appeal. The artists of the *Brücke* group from Dresden (Kirchner, Schmidt-Rottluff, Nolde, Otto Mueller, Heckel and Pechstein), those of the German *Blaue Reiter* group (Marc, Macke, Campendonk, etc.), of the Berlin *Sturm* and other German and Flemish expressionists (Beckmann, Klee, Kandinsky and Masereel) became pioneers in this field of new expressive design. They recognized that it was best for the graphic

artist to be his own wood-cutter and printer if new ideas were to be realized success-fully. Of the three co-founders of expressionism, the Dutchman van Gogh, the Norwegian Edvard Munch and the Swiss Hodler, Munch frequently and van Gogh occasionally employed the etching, the woodcut and the lithograph. Munch often used the natural grain of the wood in his cuts.

At the same time as expressionism—and since that time—various art movements (the Cubists, Futurists, Dadaists, Surrealists, Abstracts, etc.) have picked out the graphic techniques and discovered new territory. As a contrast to the attempts of the ex-pressionists for more passionate expression, there was a counter-movement for a new objectivity and, more especially, a new classicism. Valloton and a number of Impressionists were inspired by the decorative charm of Japanese cuts. Orlik was too, and around the turn of the century he twice travelled to Japan; a number of his wood-cuts and etchings give evidence of that influence. In some etchings, cuts and lithographs modelled in the style of the ancients by Picasso, Maillol and Matisse the striving after a new classicism can be felt. The same applies to a number of Gerhard Marcks' wood-cuts which deliberately disassociate themselves from eruptive expressiveness. A rather restrained form of expressionism can be seen in Rouault's aquatint etchings and resist techniques. Rouault occasionally also overworked heliogravures. Apart from his poetic illustrations, religious themes were the subject of many of Chagall's lithographs and imaginative etchings, in which, like Picasso, he incorporated the resist method to some extent.

Besides Picasso, Chagall and Matisse, the Frenchmen Braque, Bonnard, Raoul Dufy and Clavé were of particular importance to the development of lithography in the 20th century. Mention should be made of the Germans Hofer, Kokoschka, Barlach and Dix, of the Norwegian Edvard Munch, and of the Englishmen Henry Moore and Sutherland. In other European countries too, as well as America, the interest of modern artists has come to centre more and more on lithography. Apart from this, all the different styles which have arisen since Impressionism intermingle and pervade our world. The decisive factors in their appraisal should be seen not so much in terms of their aims, but in terms of their truthfulness, power of expression and pictorial quality.

Everyone sees the material, its content is only seen by those who have something to add to it, and its form remains a secret to most.
Goethe

Part of a juggler's poster, Berne, c. 1840.

Playing cards from the Upper Rhine, c. 1460.

Diana and Actaeon Virgil Solis. 1514–1562.

Nach Chriſtus gepurt.1513.Jar.Adi.j.May. Hat man dem groſmechtigen Kunig von Portugall Emanuell gen Lyſabona pracht auß Jndia/ein ſollich lebendig Thier. Das nennen ſie Rhinocerus.Das iſt hye mit aller ſeiner geſtalt Abconderfet.Es hat ein farb wie ein geſpeckelte Schildtkrot.Vnd iſt võ dicken Schalen vberlegt faſt feſt.Vnd iſt in der gröſ als der Helfandt Aber nydertrechtiger von paynen/vnd faſt werhafftig.Es hat ein ſcharff ſtarck Horn vorn auff der naſen/Das begyndt es alweg zu wetzen wo es bey ſtaynen iſt.Das doſig Thier iſt des Helfſantz todt ſeyndt.Der Helffandt furcht es faſt vbel/dann wo es Jn ankumbt/ſo laufft Jm das Thier mit dem kopff zwiſchen dye fordern payn/vnd reyſt den Helffandt vnden am pauch auff vñ erwürgt Jn/des mag er ſich nit erwern.Dann das Thier iſt alſo gewapent/das Jm der Helffandt nichts kan thün.Sie ſagen auch das der Rhynocerus Schnell/Fraydig vnd Liſtig ſey.

Rhinoceros Albrecht Dürer. 1515.

211

Hercules Christoph de Jegher; after Rubens, about 1600.

Family of satyrs Urs Graf, 1520.

St. Christopher
Hans Baldung Grien.

The witches Hans Baldung Grien, 1510.
Chiaroscuro woodcut.

1. *The actor Otani Onij* Sharaku, c. 1795.
2. *Actor* Shinagawa Takumi, 1953.
3. *Disparate No. 3* Francisco de Goya, c. 1800.

Une semaine de Bonté Elément La Boue.

Le Lion de Belfort Max Ernst, 1934.

Portrayal of the Buddhist goddess Guanyn.

Rubbing of a stone relief, Schansi Province, Tang
Dynasty 618–907.

Rats and mushrooms Katsushika Hokusai, c. 1820.

Two Japanese blocks.

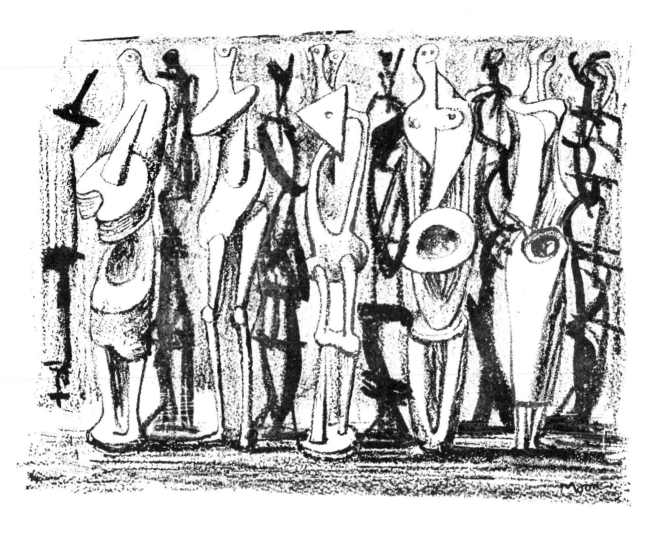

Colour lithograph Henry Moore.

218

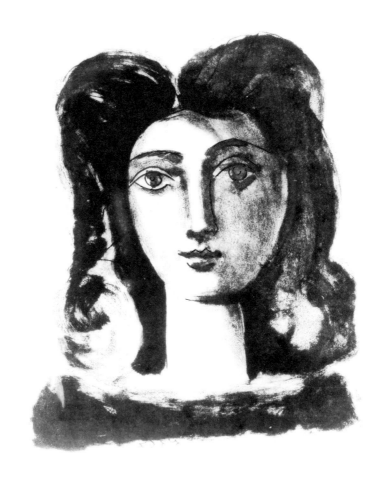

Girl's head Pablo Picasso, 1947.

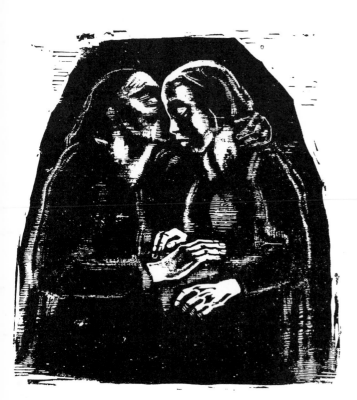

Meeting Käthe Kollwitz, 1928. Woodcut.

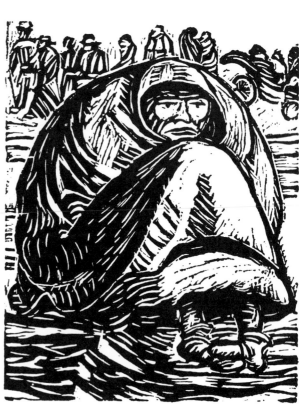

Poverty Ernst Barlach, 1918. Woodcut.

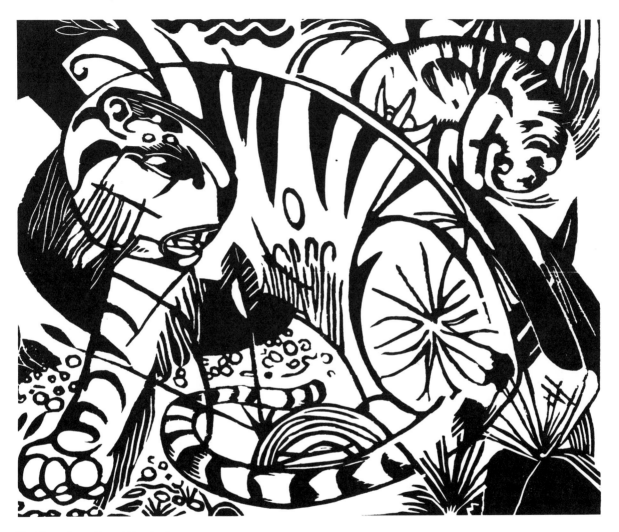

The Tiger Franz Marc. Woodcut.

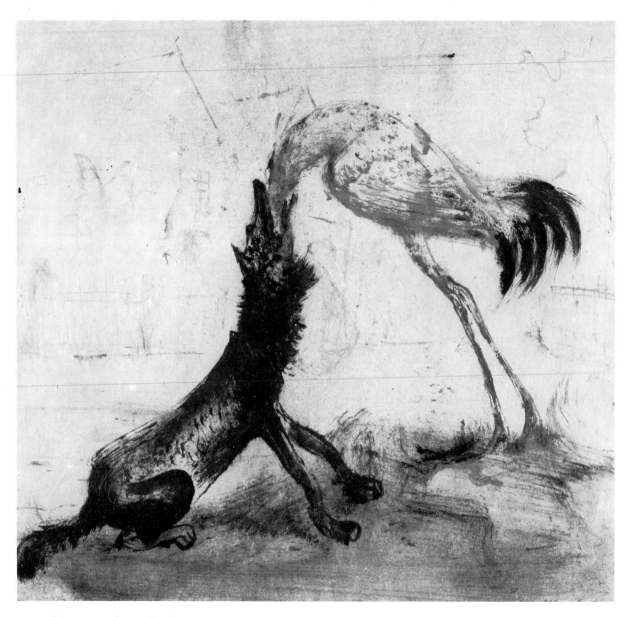

Reynard the Fox Josef Hegenbarth.

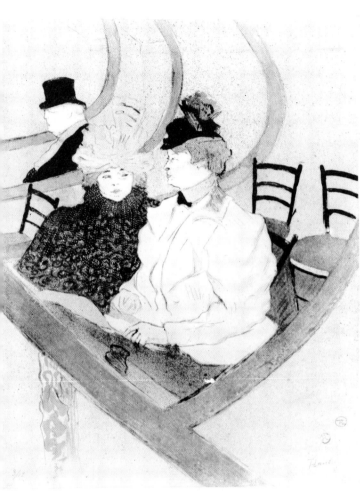

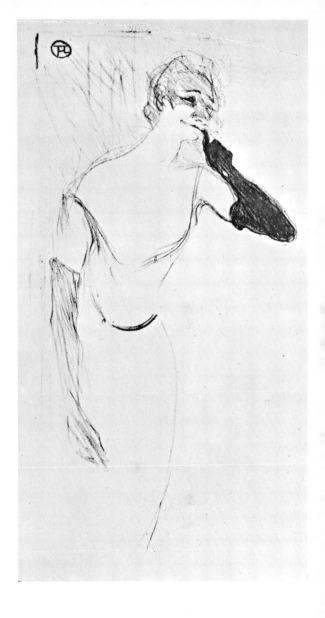

a grande loge Henri de Toulouse-Lautrec; 1897.
Colour lithograph.

Yvette Guilbert Henri de Toulouse-Lautrec, 1894.
Colour lithograph.

Leaves Imre Reiner.

Horse's head Imre Reiner.

224

Bull Ewald Mataré.

Index of artists

Index of Innovators, Engravers and Printers

Figures in bold type denote illustrations.

Glossary

Abstract art	Elimination of the representational in favour of a so-called absolute art similar to music. Also called non-figurative art.
Abstraction	The mental process of forming an idea of a characteristic which is perhaps common to a number of objects.
Aquatint ground	Porous surface of an aquatint. Variations of texture can be obtained by preparing the ground with resin and then etching it.
Aquatint technique on metal	Etching method in which impressions of great tonal variety are obtained by using an aquatint ground.
Aquatint technique on stone	Derived from the aquatint technique on metal. Spray technique with lithographic ink on stone. Surfaces previously treated with gum arabic or stencils will remain light.
Art Nouveau	A style—mainly of architecture and interior decoration—which spread across Europe in the 1890s. It was based on a naturalistic conception rather than a formalized type of decoration. In Germany the movement was called *Jugendstil* after the magazine *Jugend* (youth) published in Munich.
Asphalt lacquer or varnish	Used to mask metal surfaces which must not etch. Together with wax and resin, it represents one of the three essential components of an etching ground.
Backing paper	Part of stencil paper.
Batik	Method of hand-printing textiles by coating with wax the parts not to be dyed.
Bauhaus	School of architecture, design and craftsmanship. Founded in 1919 at Weimar, moved in 1925 to Dessau. Cultural centre of modern design for nearly all free and applied fields. Representative of aesthetic materialism and precurser of abstract art.
Bistre	Greenish-brown chalk; also watercolour made of greenish-brown beech-coal.
Blauer Reiter (blue rider)	Group of German artists founded in 1911. The most important members were Kandinsky, Klee, Marc, Macke, Campendonk, Scharff and Weissgerber. Carried on by the Neue Sezession.
Blind blocking	Relief printing without colour. Intaglio impression, e.g. letter or picture symbols, seals, ornaments impressed on strong paper or cardboard.
Block-books	Early form of illustrated book with woodcuts, in which the text and illustrations were cut together from the same block. Contemporary with books printed from movable type and illustrated with separately cut blocks.

Blue and white printed calico	Fabric printing method on linen; the patterns come out white against blue.
Brick cut	Relief print from a brick-block.
Burin	A cutting tool with a blade ground obliquely to a sharp point, used for creating fine lines in a copperplate engraving.
Burnisher	Used for polishing the etching plate smooth after it has been corrected with a scraper to obtain highlights. A drop of oil simplifies the process.
Burr	The shaving of metal turned up at the sides of the furrow in a dry-point etching (copper or zinc).
Carborundum	Artificially produced whetstone for sharpening engraving and woodcutting tools.
Chiaroscuro woodcut	*Chiaroscuro* means the balance of light and shade in a picture. The first artists to employ this method were Baldung-Grien, Cranach and Wechtling.
Cliché verre	Glass engraving—glass negative produced manually by the pre-Impressionists.
Collage	A picture built up from various materials, mainly paper stuck on to canvas or a similar ground. See also montage.
Colophonium, Colophony dust	See resin dust.
Composition	The art of combining elements of a work of art into a visual whole.
Copper engraving, Copperplate engraving	Intaglio printing method from a copperplate on which a drawing has been cut with a burin.
Copperplate press	For a detailed description see the illustration on page 109. A press with rotating steel rollers for printing etchings and copper engravings.
Copying press	Press used in commercial businesses for letter-books.
Craquelure	Fine cracks on the surface of a painting caused by shrinkage.
Crayon manner	Creation of chalk-like effects, obtained by a combination of etching and engraving techniques.
Cubism	A style based on cubic forms created and developed in many countries since about 1910. By giving an account of the whole structure of any given object and its position in space, Cubism aimed to add firmness to the impressionist approach and its lack of firm outline.
Dabber (swab)	Mushroom-shaped tool stuffed with bits of material, cottonwool, etc., and covered with leather. Used for forcing ink into the incisions of an etching or engraving plate.

Dada	The first word come across when the *Dictionnaire Larousse* was opened at random in order to find a suitable name for that group of artists.
Dada, Dadaism	Artistic movement (since 1917) based on primitive modes of expression, such as the babbling of a child. Deliberately revolutionary—anti-art and anti-sense—intended to outrage and scandalize. Word derived from the French *dada* (hobby-horse).
Decorative	Purely ornamental, maintaining and stressing the surface.
Die Brücke (the bridge)	Small but significant group of expressionist artists founded in 1905 in Dresden (Kirchner, Heckel, Schmidt-Rottluff, Pechstein, Nolde, later Otto Mueller and others).
Direct print	Direct impression from the plate on to paper.
Dry-point (also called pointe sèche)	Unlike the acid method of etching, incisions are made into the metal plate with a steel needle. The needle itself is also often referred to as a dry-point.
Dynamic	Active, marked by energy.
Eclectic	Selective. An eclectic is a person who uses an eclectic method or approach (e.g. philosophers who adopt and try to combine doctrines and methods of various other systems). In art: composed of elements and styles drawn from various sources.
Engraving needle	Used in a similar way to the etching needle for etching, especially for engraving metal plates. Its cross-section can be three-edged, four-edged, round or oval with a slanted point.
Etched line	Lines are created by making incisions in a metal plate which has either been covered with etching ground or has previously been warmed. The plate is then immersed in an acid bath and the lines are bitten. An impression of this is made by the intaglio printing method.
Etching ground	Consists mainly of wax, asphalt and resin. Available commercially in solid and liquid form. Used for stopping out those parts of an etching plate which are not supposed to be attacked by the acid bath. See also aquatint ground.
Etching ink	Printing ink for intaglio and surface printing. Available in tins and tubes, it can be thinned with printing oil if necessary.
Etching needle	A cutting needle with a handle, employed in all the various etching techniques. The steel needle cuts the drawing into the etching plate.
Etching paper	A plate paper with a minimum weight of 200 grams per square metre. Perfectly suited to intaglio printing.
Expressionism	The art of expressiveness. The aim is to create a picture which mirrors the artist's emotional state by means of distortion of line (deformation of subject) and exaggeration of colour or its symbolic significance.

230

Fabric print	Printing on cloth.
Flange	The cut rim of an etching plate, which protects the printing paper from being cut during the printing process; printed as blind blocking.
Flock paper	Precursor of today's velour paper. The surface was hand-printed with wooden blocks coated with a thick layer of glue and then strewn with wool dust (flock).
Foil	A transparent sheet, available in various strengths or thicknesses in art shops; widely used in commercial graphic art.
Folding stick (paper folder)	Book-binding tool for the folding and smoothing out of paper, parchment and linen. Usually made of horn, bone or ivory.
Formal	Concerned with the artistic form, as opposed to the content. The formal is the medium through which the content can be realized. See also pictorial techniques.
Frottage	A rubbing of an object put under a piece of thin paper; used to obtain textural effects in abstract or semi-abstract paintings.
Futurism	An art movement, founded in 1910 in Italy by Marinetti, which aimed towards a future art. Events taking place at different periods in time are often recorded in one picture. Concerned with a more dynamic approach to the conception of space; expressed by interlinked motifs.
Glaze	Transparent or translucent colour which modifies the effect of a painted surface. Application is similar to the watercolour technique. Madder red and Prussian blue will show through the surface particularly well.
Gouge	Woodcutting tool; a chisel with a concave-convex cross-section.
Grain	The granulated surface of a printing plate or stone.
Graining	Treatment of a litho stone with screened sand and water in order to obtain a roughened drawing surface.
Graver	(Also called burin.) Sharply pointed graving tool used for wood engraving and copper engraving.
Grindstone	A flat, circular stone used for grinding, shaping and smoothing.
Grisaille	A painting executed in a series of greys (mixture of black and white).
Gum arabic	Plant resin which, when dissolved in water, combines in a special way with a lithographic stone. The stone changes colour and then shows a particular reaction towards grease. Important in lithography.
Hand graining	Graining by hand. The graining stone is moved over the stone which is later to be drawn on.

Hand vice	A file-shaped gripping device with screw-on jaws for holding an etching plate. Used in the preparation of etching plates for line etching and aquatint.
Hatching	Shading carried out in parallel lines.
Heliogravure	Prints made from an intaglio plate by photographic methods. Also called photo-gravure. A copperplate covered with a light-sensitive layer is exposed under a photographic slide, sprinkled with powdered resin, etched and printed like a copper engraving.
Hollow chisel	Cutting knife which leaves grooves in the shape of a U in cross-section.
Homogenous print	Print from a roughened zinc plate (offset-plate) which has been drawn on with spirit varnish. Different tones are achieved by varying the thickness of the varnish. The result is a homogenous printing surface without the use of a screen, dots or grain.
Indirect printing	A printing process in which an inked impression is not made directly from the plate on to the paper; e.g., in the case of offset printing, via a rubber blanket.
Intaglio printing	The parts below the surface of a printing plate pick up the ink and print an impression of the design on paper or cardboard.
Krems white	A colour consisting of basic carbonate of lead which covers well and is fast to light, but slightly poisonous.
Lacquer film	A thin film of lacquer which develops when a specially prepared and thinned lacquer is poured, painted or sprayed on to a screen printing frame as a block-out agent.
Lead cut	Relief print cut out of a lead-block.
Lino cutter	Steel blade with a shaped handle for cutting lines into lino.
Lithographic ink	Special ink for the lithographic machine press and hand-press.
Lithography	The most well-known surface printing technique. Originally drawings were made on blocks of calcerous limestone from Solnhofen (Germany) with greasy chalk or ink.
Litho grinding stone	A small stone which is used for graining by moving it over the lithographic stone.
Mask	A layer of lacquer used for blocking out the screen in screenprinting, applied to those parts of the screen where the pigment is not supposed to be squeegeed through.
Masking stencil	Usually referred to as glue stencil. The most basic type of stencil used in screen-printing; now used only rarely.

Material print	Impression of various articles or pieces of material which have received a layer of ink from a printing roller. Usually a part-printing process.
Mattoir	An engraving tool used for stipple and crayon engravings; it is like a tiny club with sharp points projecting from the head, and produces lines made up of small dots, similar to chalk lines.
Merz pictures	Special kind of papier collé by Kurt Schwitters. The name is a result of circumstances (see page 38).
Metal engraving	A method similar to the woodcut. A 15th century white-line engraving on a stippled ground made with punches and knives.
Mezzotint	A method of engraving in which smoother surfaces and lines are created on the roughened surface of a metal plate with a scraper and burnisher; they will then print light.
Monoprint	A simple print which cannot be reproduced again in exactly the same way.
Montage	Built-up composition; a picture made by combining several separate pictures.
Montage relief print	A print from various pieces of material (e.g. cardboard, wood, metal, wire, etc.) and inked with a printing roller.
Motif	Artist's stimulus to action, usually a visual experience.
Moulette	An instrument rather like the roulette, with a barrel-shaped head equipped with teeth which produce grainy effects and rough surfaces.
Muslin	A ball of muslin is used for rubbing the printing ink from an engraved plate, leaving the ink in the furrows.
Needle point technique	A method of registering the various colour plates used in multicolour printing; needles are passed through points in diagonally opposite positions.
Negative technique	A method in which the positive image is reversed and vice versa, e.g. dark strokes against a light ground appear as light against dark; or relief as intaglio.
Niello	A medieval metal engraving in which a dark composition was fused into the engraved lines of the pattern. Precursor of the copperplate etching in graphic art, which developed from the copper engraving.
Offset	An indirect printing process in which an inked impression from a zinc plate is first made on a rubber-blanketed cylinder and then transferred to the paper being printed.
Oilstone	A whetstone, dampened with oil instead of water, used for sharpening engraving needles, burins and woodcutting knives.

Organdie print	A screenprint where organdie (usually cotton organdie) was used for covering the frame.
Outline plate	As opposed to plates for surface printing, there are also plates which reproduce only the outline.
Pad	A wooden board splayed towards the end and equipped with a leather strip. It is detachable and can be adjusted in size and width to the printing stone (lithographic stone). The pad presses the paper and the printing cardboard firmly to the stone during the printing process.
Paper stencil	A cut-out. See chapter on screenprinting.
Paper stencil prints	Impressions of inked paper on cardboard stencils.
Pattern	An artistic design breaking up the surface within a preconceived system.
Photogram	An impression of a glass drawing or of any other flat objects made by placing the object on light-sensitive paper.
Photographic stencil	Used for producing a screen photographically. There is an indirect and a direct method.
Photomontage	Montage built up of various photographic images to form a new pictorial entity.
Pictorial techniques	Creative means such as dots, lines, surfaces, texture, shape, structuring, light/dark, colour contrasts, colour harmonization, etc.
Pigment paper	Paper coated with a layer of dyed gelatine. Employed in the photographic technique of screenprinting.
Plaster cut	Relief print from a block cut from plaster.
Plate	A prepared surface from which printing is done.
Pressboard	Compressed paper fibre. Used as a substitute material for dry-point etching, it is strong, highly glazed board with a polished surface.
Printer's ink	Special ink for printing set type and plates.
Punch	A tool with conical steel rods faced with small circles, lines and ornamental shapes, which are transferred on to metal or wood by means of a hammer.
Red chalk	A red ochre chalk pencil made of earthy hematite; a pigment similar to English red.
Reed pen	A drawing pen for writing and drawing made of reed, usually equipped with a nib at the bottom to retain the ink longer.

Registration	Accurate overprinting. When accurate registration is required in screenprinting, an apparatus is employed to locate the screen each time in an identical position in relation to the printing table.
Registration mark	Dots or crosses at the margin of a printing plate, placed to ensure accurate registration in multicolour printing.
Relief printing	The raised parts of the block will catch the printing ink (inking is usually done with a roller) and print on paper.
Resin dust	Sprinkled over metal plates intended for an aquatint ground.
Resist drawing	Technique in which paints and inks are applied one after the other, separating on contact. The bottom colour makes the top colour crack off during the drying process, thereby revealing the drawing.
Resist printing	An etching technique in which the drawing is placed in cold water before etching. An aquatint ground is then applied, which results in broad tonal lines. See p. 142.
Retroussage	A tonal effect achieved by passing a ball of muslin over an inked plate without wiping all the ink off, but smearing some of it across the etching plate, which will then print.
Rocker	A toothed chisel-like tool used for roughening the surface of a metal plate to be printed by the mezzotint process.
Roulette	An engraving tool with a spur-like wheel projecting from the head, which stipples dots over a plate similar to the grainy quality of chalk.
Rubber cut	Relief print cut from a rubber block.
Sand box	A shaker for sprinkling colophony dust on to an inked metal plate; used for aquatint etchings.
Scraper	A three-edged iron with a handle, the sharp edges of which are used for scraping off the incised lines (burr) of an etching plate and scraping the roughened surfaces smooth again.
Scraperboard	A stiff board coated with a layer of white pigment, on top of which is another extremely thin, matt layer of black; the drawing is scraped in this top layer, resulting in a negative effect.
Scraperboard technique	White dots, lines and surfaces are scraped from the scraperboard with needles, fine knives and razor blades.
Scraper technique on glass	Lines, dots and surfaces are scratched out of a glass plate coated with paint, and are then copied on to photographic paper.

Screen	A surface divided into dots which creates half-tones.
Serigraphy	The term serigraphy is widely used to describe the technique of silk-screen printing when referring to the production of artists' prints. The screen is not produced photographically, but manually.
Silhouette	Representation of the outline of an object.
Silk-screen frame	(Or screen frame.) A rectangular frame made of wood and used for screen-printing. It is covered with silk or organdie and joined to a movable wooden board of the same size on which the material for printing is placed.
Silk-screen printing	A type of screenprinting in which the screen frame is covered with silk.
Slate cut	Relief print from an incised slate plate.
Soft-ground etching	Etching technique with a soft, gelatinous etching ground; a thin sheet of paper is laid on this ground, through which one draws by a special tracing method. Etchings printed from these plates have a soft and grainy line and look like a pencil or chalk drawing.
Spray painting	Ink or paint is sprayed on to the picture surface. Areas which are to remain white are blocked out with paper cut-outs.
Squeegee	A flat blade of rubber (employed in screenprinting), supported by a wooden handle, and used for forcing screenprinting inks through the screen mesh.
State	Each pull from an etched or engraved plate (or a lithographic stone) marks a definite stage in the development of the work and is called a state.
Steel-facing	Coating of an etched copper plate by electrolysis with a microscopic film of steel, in order to harden it sufficiently to allow the printing of large editions of several thousand copies without noticeable wear to the plate.
Stencil paper	Available in art shops, this consists of two sheets of paper—the actual stencil paper and backing paper. For its application, see page 175.
Stipple engraving	Old type of copper engraving made by stippling dots over a grounded plate.
String print	Print made from string glued to a surface and then inked.
Structure	From the Latin *struere*, to heap up, build. The individual and unchangeable composition of matter, e.g. the characteristic grain of wood. Paper has a fibrous structure, and metal a crystalline structure.
Stylus	A hard, pointed, pen-shaped instrument which was used for cutting inscriptions in wax plates.
Subject	Something represented in a work of art.

Surface printing	(Also called *planar* or *planographic printing*.) In this process the directly drawn on image is taken from the surface or plane of the block (stone or zinc plate). Flat-lying parts will accept the ink when it is rolled on and print it, while the wet parts which were not drawn on will repel it.
Surrealism	A modern art movement representing the weird and fantastic; visions of a dream world created with realistic means and closely linked to psychoanalysis and literature. Most famous representatives: Max Ernst, Chirico and Salvador Dali.
Tapa	A coarse cloth used as a wall-covering; made in the Pacific Islands from the bark of the paper mulberry and other plants, decorated with earth-coloured geometric patterns; either painted or printed by making a rubbing over a relief block.
Topography	Graphic delineation of a place or region, showing detailed features of soil, elevations, woods, rivers, roads, etc.
Transfer-paper	Specially treated thin paper for the production of transfer prints.
Transfer print	Transfer of a drawing from the lithographic stone on to the printing stone. Also used for the transfer of a drawing from paper on to stone.
Transfer printing ink	The difference between this and ordinary printing ink is the higher degree of soap and thick grease.
Transparent paper cut-outs	A technique developed from cutting, folding and placing transparent paper.
Varnish printing ink	Printing ink diluted with linseed oil varnish or artificial varnish. For book-printing, offset printing and lithography.
Varnish work	An ornamental technique taken over from the Japanese and modernized in Europe, in which the negative effects of an engraving and a relief-like quality are achieved by carving.
Veduta	A painting or drawing of a town(scape). A typical *vedutist* was the Venetian Canaletto (1720 to 1780).
Velour papers	Wallpaper with a printed velour surface or multicoloured velour pattern. Manufacture is similar to that of flock papers.
Vernis mou	See soft-ground etching.
Vignette	A small decorative design on printed work.
'V' tool	A tool similar to a gouge, used for detailed cutting of a lino or soft-wood block.

Washable stencil	A negative technique often chosen as a screenprinting stencil for artist-produced prints.
Washing-out tincture	Dark brown, thick tincture for the treatment of lithographic stones. Consists of turpentine, melted asphalt with the addition of virgin wax, Venetian turpentine, wood-tar and spike-oil. Available from art shops.
Wax sgraffito	A decorative technique in which the ground is coated with layers of wax colour (wax crayons are used for this purpose), the top layer then being scratched with a design revealing the lower layer.
White spirit	Used for cleaning rollers.
Wind-flag	A piece of cardboard between 30 cm and 40 cm (12 in and 16 in) long, which rotates round a rod, to which it has been attached, when moved about. Used for speeding up the drying process.
Wire sieve	A rectangular wire mesh with a handle which is employed for creating a spray pattern on paper by drawing a brush dipped in either ink or paint across the wire mesh.
Wood engraving	Block usually of boxwood, cut across the grain (end-grain timber). It is cut with graving tools called gravers or burins and then printed by the relief printing method.
Xylographer	A wood-engraver or woodcutter.
Xylography	The art of wood engraving or woodcutting.